Praise for

D1650609

'These selfies are exquisite vignett
observant, sometimes poignant, an
elegance of the original French appaᵣᵉₙₜ ᵢₙ ₜₕᵢₛ ᶠᵢₙₑ ᵉₙ₉ₗᵢₛₕ
translation.'
— Piers Paul Read

'I love this French experimentation with form, which makes it an
intriguing and compelling read.'
— *Bookword*

'It all hangs together beautifully – an examination of "selfies"
over the centuries, and a highly varied account of the author's
own life, linked by the imagined selfies of her own, and with a
nice balance of humour and genuine pathos.'
— *Goodreads*

'The writing is consistently witty, vivid and punchy despite its
economy, and throughout, perfectionist literary translator Ros
Schwartz sheds as powerful a light as the author on hitherto
hidden stories of women's self-portraits and the darkest of family
secrets.'
— *#RivetingReviews*

'Brilliantly intelligent, touchingly intimate, self-critical and
complex.'
— *NB Magazine*

'Weil covers a distance most writers wouldn't manage in a book
twice this size. In the selfie era, she reminds us that what truly
makes us interesting cannot be captured in a freeze-frame.'
— *Buzz Magazine*

'In her use of the term "selfie" to discuss works of art throughout
history, Weil rescues the selfie from its conceitedness, proposing
that it can be become a starting point, and not necessarily an
enclosed mode of self-regard.'
— *Splice*

By the same author

At Home with André and Simone Weil

Sylvie Weil has published several collections of short stories, and contributed short fiction to literary magazines. Her writing for young adults has won the prestigious Prix Sorcières in France. Her critically acclaimed memoir *At Home with André and Simone Weil* (2010) has been translated in several languages. She lives in New York and Paris.

Roz Schwartz is the award-winning translator of over eighty works of fiction and non-fiction, including the 2010 edition of Saint-Exupéry's *The Little Prince*. A Chevalier de l'Ordre des Arts et des Lettres she was awarded the 2017 John Sykes Memorial Prize for Excellence.

SELFIES

Sylvie Weil

SELFIES

Translated from the French by
Ros Schwartz

Les Fugitives

This first English-language edition published in Great Britain
in June 2019
reprinted in November 2021
by Les Fugitives
91 Cholmley Gardens, Fortune Green Road,
London NW6 1UN
www.lesfugitives.com

Originally published by Libella, Paris, France
(*Selfies*, 2015)

Typeset in London by CB editions
Printed in England by TJ Books Limited, Padstow

Cet ouvrage a bénéficié du soutien des Programmes d'aide
à la publication de l'Institut français.

ISBN 978-1-9993318-2-5

Self-portrait at the organ

Sofonisba Anguissola, a highly popular artist in her day and official court painter to Philip II of Spain, depicted herself at the spinet in 1561. Perhaps she was also a gifted musician. A young lady from a good family was expected to play an instrument, even if painting was her vocation. Sofonisba (who left at least fourteen self-portraits) is seated at her instrument, her hands over the keyboard, fingers poised to play. In this upper-body portrait, the artist turns outwards, her large, hazel eyes staring directly into the viewer's. Her expression is solemn. She is soberly but elegantly dressed in a dark-coloured conventional outfit comprising a lace-up blouse with a small ruffle. The sleeves of her bodice are long and tight-fitting. An almost masculine, short-sleeved doublet with short, puffed sleeves and fastened with frogging completes her dress. The absence of jewellery and her modest hairstyle suggest she is in her own home. On the left, the dark-skinned figure in the shadows – a nanny or servant with sharp features and a sombre gaze – appears to have been added in because she seems

detached from the scene. Some believe that the presence of a servant made the portrait more 'respectable'.

I will paint a music lesson that took place in 1978, in a church crypt. I'll depict myself seated at the organ in a classic pose: a three-quarter view of a young woman, chest and face turned towards the spectator, her hands on the keyboard, or rather, one hand on each keyboard because this organ has two. My very dark hair is gathered at the nape, and my eyes are rimmed by large glasses with a pink plastic frame, which makes them look smaller than they are. My expression is earnest, possibly slightly anxious. My body is engulfed by a long, baggy, royal-blue man's cable-knit pullover with a roll-neck. The viewer will rightly infer that it is chilly in the crypt. The organ console is made of dark, varnished wood that has a slight sheen. The scene is bathed in a wan, golden glow coming mainly from the lamp illuminating the score on the music stand. The teacher, an elderly gentleman wearing a long, anthracite-grey wool coat, is seen in profile, seated to the left on a simple church chair. He holds himself upright, but without stiffness. He is attentive. His hair and moustache are grey. His nose is rather long.

*

For the sake of decorum and to avoid portraying myself alone in a crypt with a gentleman – of a venerable age, admittedly – but all the same, I'd like to add the sacristan standing in the background. But he's a busy man who doesn't have time to hang around in the crypt. He's Basque, a former shepherd. Lost sheep, he knows a thing or two about, he says – men in creased suits, faces crumpled from a sleepless night, who rush into the church looking for a priest to hear their confession right away and fast, before the departure of the train that will take them home to their provincial backwater where they really don't want to have to confess. That is because the church is close to the Gare Montparnasse. I bump into them, those rumpled men in a hurry, when I come early in the morning. I always arrive before the teacher. I sit down at the organ and practise the piece I am to play for him one last time, wondering whether I'll find the courage to play it in front of him. I hear his footsteps on the flagstones long before catching sight of him. The crypt echoes, and he walks with a regular, firm stride. He materialises from the shadows just in front of the altar, his grey wool coat flapping around his calves. He makes a rapid genuflection and crosses himself before sitting down on a chair, not without having greeted me with extreme politeness, as if I were in my own home and he a mere visitor. I play my piece, then I turn to him,

always afraid I'll see an expression of consternation or contempt. Not at all. He looks at me amiably, and declares, without smiling:

'Madame, that is perfect. You are becoming a real organist.'

His words resound in the crypt, like his footsteps earlier. Then he remains silent for a moment. I wait. He opens his mouth again to add, with a little shake of his head, as if what he is about to say is of no importance:

'Now, you will permit an elderly teacher to make a few observations.'

He rises and without haste comes over and sits on the organ seat next to me, muffled up in his big grey coat. He demolishes each bar, each note, only to reconstruct the note, the bar, immediately. Each chord is an edifice that must hold up perfectly. The elderly teacher builds solidly. So solidly that many years later, those chords still hold. When he is beside me, sitting so close, I never look at him. My friends fall about laughing when I tell them that I think my teacher has a moustache but I'm not absolutely certain because I daren't look up at him. When he raises my wrist to correct the position of my hand, he inquires respectfully:

'May I, madame?'

I long to have a lover who'd ask me: 'May I, madame?'

He says, as if it were a novelty, that I'm lucky to live at a time when women are allowed to wear trousers,

which are much more practical for playing the organ. A skirt is less convenient for the pedal board. I daren't reply that women have been wearing trousers for quite some time. He is so intimidating with his grey moustache, his urbane manners, his quaint way of speaking and his genuflections before the altar. I say very little to him. Later, a long time after his death, I learnt that he would have been touched and delighted to know that he was giving lessons to Simone Weil's niece. But at the time, that was something I'd have been careful to keep from him, even if I hadn't been so intimidated. This is perhaps the moment to mention that, regretfully, Simone Weil's family, who thought that piano lessons were part of a well-bred young lady's education, would never have dreamt of making me learn to play the organ! It was not until I was already an adult that I fell in love with that instrument discovered almost by chance, the way you fall in love with a person.

The elderly teacher would often remind me that you must play each bar with one eye already on the next, so as not to be caught unawares. It was when he was speaking on this subject that I heard him laugh – the one and only time ever. He recalled one of his pupils, a very pious English spinster, who had replied: 'Oh! monsieur, God alone can see the future.' I didn't see him laugh because I never looked at him, but I definitely heard him laugh, as he sat beside me.

One morning I am working with him on the Bach chorale, *O Mensch, bewein' dein' Sünde gross*. We come to the last line. I play. The last line is hard to describe. It begins with a fairly normal, gentle ascending chromatic scale that has a certain regularity. And suddenly, having begun to descend, instead of bringing us just as gently back to the original key, Bach, who loves surprises, introduces a moment of mad chaos by subjecting us to an unexpected chord, belonging not only to a different key, but to a different world, both nerve-jangling and extremely soft, before finally plunging towards the resolution and back to a normal, reassuring world. I reach this chord that's so startling and so poignant. But I am too worried about keeping one eye on the next bar to avoid playing a false note to relish the joy of abandoning myself to that chord with the mixture of resignation and pleasure it invites. And while I'm fretting about false notes, from beside me comes the calm, controlled and ever-polite voice:

'Let us hold this chord, madame. This is the orgasm.'

That chord in C-flat major has stayed with me ever since. As has that moment when I realised the extraordinary passion that can lurk beneath a grey coat and quaint manners.

A little later, when I return the key to the crypt, the sacristan gently tells me that with the flu epidemic that winter there'll be deaths, which means funerals,

and funerals are always better with music and he'll be recommending me to play the organ.

'That way, my dear little lady, you can earn some money. You'll like that, won't you?'

And the sacristan gratifies me with a sly wink.

Self-portrait as a capital letter

Around the year 1200, a German illuminator by the name of Claricia portrayed herself on the page of a psalter, at Psalm 52, gleefully swinging by her arms from the tail of a large capital 'Q' (QUID gloriaris in malicia tua – *Why dost thou glory in malice . . .). More accurately, it is the lithe, slender body of the young woman that forms the tail of the illuminated dropped capital 'Q' ornamented with tangled vines against a blue, red and green background. Claricia draws but doesn't paint herself; only three items of her dress are coloured, all of them red – the lining of her sleeves, her shoes peeping out from the hem of her dress, and her necklace.*

The figure-hugging dress conceals nothing of her long legs or of her tiny rounded belly, very much in fashion in the Middle Ages. The flared sleeves with their red lining appear to be floating or flying parallel to her body. Her head is bare, so we know she's neither a nun nor a married woman.

What do we know about this Claricia swinging casually among

the Latin words that mean: 'All the day long thy tongue hath devised injustice: as a sharp razor, thou hast wrought deceit'? It is amusing to imagine a playful young apprentice miniaturist who insists on signing her work in this way, and then writes her name either side of the delicately drawn face. But perhaps instead she is an elderly nun wistful for the days when she was a pretty girl, with lovely fair braids, large eyes and a rosebud mouth, pointing her supple feet in their fine, red shoes skywards.

I will paint my self-portrait as a letter 'I' against a background the warm hue of ancient parchment. A perfect upright, slender, graceful adolescent girl, wound like a vine around a rope dangling from a ceiling that is either invisible or covered in verdant foliage, since this is an illumination. An adolescent girl with braids down to the small of her back, a deep blue-black colour in contrast to her faded clothes: a very pale blue polo shirt and shorts a slightly stronger but not bright blue. Her arms extend high above her head, her hands gripping the rope. Her bare, shapely legs are also extended, forming with the rope a double line drawn in a dark sienna that creates texture. Her face is partially hidden in the hollow of her shoulder. You can see one wide-open eye and a very dark eyebrow, and a hint of a chubby, baby cheek.

*

The covered playground, grey and freezing as the play-ground of a Parisian lycée can be, is full of girls jostling one another and laughing in front of four long, ominous-looking ropes suspended from the ceiling. Tall rectangular windows are open onto the outdoor yard, which is also grey. The girls blow on their fingers to warm them, then rub their thighs. The playground is full of thighs – fat and thin, stubby and long, all mottled red, shivering, covered in goose bumps, with marks on the flesh from the elastic of the hideous, infantilising, baggy, navy-blue regulation gym knickers. Everything is cold in the covered playground, even the smells. The smell of dust, stale sweat and body odour.

The teacher, in grey culottes, claps her hands. Her loud, sharp, unpleasant voice rings out:

'Press your knees together, young ladies, and hold on tight, for heaven's sake! Rope-climbing has long been an Olympic sport.'

'It isn't any more, madame,' retorts a know-it-all.

Will she get a detention for impudence? The teacher pretends not to have heard.

'Come on, make an effort, put your weight on the knot, cross your ankles and grip the rope with both hands, one above the other.'

Two girls swing on the ends of their respective ropes. They snort with laughter, writhe, and pretend to haul themselves up, then whine:

'Madame! I've hurt myself, I slipped and I've got a rope burn on my hand!'

'All right, that's enough, let's keep moving. Next!'

The teacher's tone is resigned, weary. I don't like this woman with her ghastly culottes and her perm that's so tight that she can probably do a headstand without disturbing a single hair. But I despise my classmates who hang limply at the bottom of the rope like idiots. I love climbing. On Sundays, I climb trees with my cousins in Châtenay-Malabry. When I climb, I'm alone, I'm free. Even in this freezing, grey school playground that's like a prison yard. From the top of the rope, I glimpse a patch of sky, grey and dark, but still a patch of sky. The outside. Freedom. I laugh at the girls shivering and milling around far down below.

'Look!' shouts one, an ungainly girl who's always making fun of others, 'she wants to be a fireman!'

I squeeze the rope between my legs, I am one with this rope entwined around my ankle. I feel the rough hemp against the soft, tender skin of my inner thighs. The teacher's furious voice rises and bounces off the ceiling:

'Come down from there at once, what's got into you? What are you waiting for?'

I don't move, I play dead. What's got into me? I have just had my first orgasm.

Self-portrait with postcard

I am intrigued by Gwen John's painting entitled Self Portrait with Letter. *It is a watercolour which she gave to Rodin around 1909, when she was his model and his lover. Obsessed with the sculptor, whom she met in 1904, Gwen John wrote him thousands of letters. In this painting, she depicts herself dressed simply in a dark, high-necked dress, her hair parted in the middle and drawn loosely back over her ears. Gazing straight ahead, she is holding a folded letter to her chest, almost at neck height. She does not press the letter to her, there is nothing dramatic or pathetic in her attitude. I don't know whether it is a letter she is going to send or one she has just received. Her gaze is opaque, earnest, a little troubled. Vulnerable. Her lips are parted, not so much to speak, it seems, but to give of herself. Not the ghost of a smile. It is hard to fathom her feelings. Neither joy nor sadness, but rather concentration and, most of all, I feel, an expectation that will not allow itself easily to be discouraged.*

I paint a young woman standing in the centre of a room whose walls are covered in drab wallpaper, a pattern of foliage and flowers in dark browns and greens. She's holding a postcard and staring straight ahead, looking bemused. Her black hair is gathered in a ponytail, and large spectacles with a pink frame add a nice colourful touch to the top half of her face. A smile plays on her lips – quizzical rather than an expression of pleasure. You can tell the young woman is wondering whether she should smile. A mattress can be seen on the floor. The rest of the furniture comprises two chairs and a table made from a board supported by trestles. On the table are books, papers and a little Olivetti Lettera typewriter, which dates the painting to the late 1970s. To the side, a large window overlooks an uninviting Parisian courtyard.

*

The postcard depicts the restaurant at Porte Maillot where he'd invited us to lunch, my son and myself. On the back of the card, a few lines: 'It's Sunday today, I've just had lunch, but neither the food nor the company were as enjoyable as when I was with you. I hope you both miss me a little. Best wishes, Gary.'

He's been gone nineteen days. A few hours before leaving Paris, he'd begged me: 'Come with me! Don't

you have anyone you can leave your son with? Find someone! Sort something out!'

He kissed my face all over.

'Come back to New York with me! Or come tomorrow. I'll pay for your ticket!'

I repeated that I couldn't come until the Easter holidays.

'But why don't *you* stay a few more days?'

'I can't. I've already been in Paris for several weeks.'

'Several weeks? But . . . I don't understand.'

'Jack wanted me to work with him without any distractions. He waited until the last few days to introduce us. But don't worry, everything will be okay. Come at Easter, I'll take care of your ticket.'

At the last minute, on the landing, he said:

'This summer, you'll move to New York. Everything's okay.'

He started going down the stairs. His long hair, his bag slung over his shoulder and his suede jacket lent him a nonchalance, gave him the casual appearance of a stage character, a sort of Figaro. On the third stair, he turned around:

'Remember we're engaged. Be faithful!'

Another step, and he turned around again:

'I change at Montparnasse, right?'

My last image of him: he smiles, waves and disappears around the stair bend. He is gone. We've known

each other for three days.

The warm, comforting, masculine smell of Dutch tobacco lingers in the air of my ugly, cramped, sparsely furnished apartment. To preserve that smell as long as possible, I avoid opening the windows. I go round in circles, I flick through a book, I turn on the radio and hear that the Islamic Republic has just been proclaimed in Iran. This news item doesn't really interest me.

The following day, Éléonore comes into my life. A joint work project, a few chapters for an encyclopaedia of the Bible for an educational publisher.

When I open the door, I see a tall, very slim young woman with huge grey-green eyes and ash-blond hair piled up in an old-fashioned chignon. 'Jean Renoir has died,' she announces dolefully, by way of a greeting. For this first session, she sports a sequinned cardigan and baggy trousers, sort of harem pants, with flat cycling shoes that don't make her look sporty. She holds out a tub of cream and a punnet of strawberries and declares guiltily:

'They're ridiculously expensive and not at all in season, but how could I resist?'

She flings her jacket onto the bed then takes out a packet of Gauloises.

'You don't mind if I smoke? I'm exhausted.'

I learn that Éléonore has a boyfriend, Antoine, that he's spending the week in London for work and that

last night, on the telephone, his voice had sounded weird. Éléonore concludes:

'You can't imagine the state I'm in. If he left me, I'd be devastated.'

That first day, we barely do any work. I ask Éléonore if she believes a man can love, truly love, a woman he has known for only three days. Yes, Éléonore believes so, she believes in these things. Me too, I want to believe in them.

Éléonore's true realm of expertise, I soon discover, is in the emotions. She demands a blow-by-blow account of how I met Gary.

As we eat the strawberries dipped in sugar and cream, I begin at the beginning: last Saturday, a dreary, grey, wet day, as a February day in Paris can be.

'Awful, days like that are awful, they're soul-destroying and drive you to despair,' adds Éléonore.

I tell her about the afternoon in this apartment that I loathe, with its hideous brown and green wallpaper from which I half-expect to see monkeys appear, its windows looking out onto a courtyard that's dingy all year round. I'd played Monopoly with my son and was wondering whether to take him to the cinema, when the telephone rang.

It was a friend of friends, a woman I see seldom. She asks me if I'd like to meet up with her and her mathematician husband at the Closerie des Lilas where they'll

be having dinner with an American colleague who's passing through Paris. The colleague is single and very keen to meet me. He is not indifferent, of course, to the fact that I'm the daughter of a famous mathematician. We belong to the same world, as it were.

Her opening words made me burst out laughing. Like to? An evening out, dinner, such a miserable Saturday that was turning out so well! For the first time in his life, I left my son at home alone. I promised him a reward, I gave him the phone number of La Closerie, slipped on my prettiest dress and set off.

It was only eight o'clock and already Rue de Vaugirard was empty. I walked fast. I was on my way to a date, to an affair, happiness, why not? My high heels clacked on the pavement, tapping out a starry-eyed girl's dream.

Éléonore listens intently to my story. She walks into the restaurant with me, she sees the red velvet banquettes, the gilded chandeliers, the mirrors, the waiters bustling about, and finally a man with broad shoulders and a square jaw, smoking a pipe.

Over dinner, Gary quizzes me about my life, my son, my work. He asks me whether I'd like to live in New York. He himself speaks little but smiles a lot. That smile and his pipe make him look both dependable and kind.

The meal over, he suggests going to meet some

friends in a café in Montparnasse. I agree, on condition we drop into my place first.

Gary is the first to spot the note on the table, written on a page torn out of a school exercise book. He reads out loud: 'Mama, you'd better come back early, I miss you.' He laughs softly and says 'How sweet,' and takes a photo out of his wallet to show me a fair-haired boy of around eight or nine playing ball. His son.

'He lives with his mother. She's doing a great job with him.' Crinkling of the eyes, pleasant smile. And the smell of honey and Dutch tobacco.

At the café, the tipsy friends greet us raucously. We huddle around a table. A mathematician from Holland, wide-eyed, repeats: 'No kidding, you're the daughter of . . . Unbelievable!'

'I was exhilarated by the crowd, the noise and the smoke. I was surrounded by clever, witty men who knew my father into the bargain. Imagine, I spent the whole evening laughing!'

Éléonore frowns. Her reply is a stark reminder:

'That's not the most important thing. What strikes me is the words you used to describe this man you've just met: dependable and kind.'

The next day, Sunday, Gary comes to pick us up, my son and me, to take us out to lunch. He rings the doorbell on the dot of midday, casually dressed in a light-coloured suede jacket. An idyllic lunch – seafood,

excellent wines, delicious desserts. Then a stroll in the Bois de Boulogne on a mild and sunny almost spring-like afternoon. Gary kisses me. Broad shoulders, pleasing taste of pipe smoke. And suddenly, my son has vanished. Panic-stricken and on the verge of tears, I cling to Gary's arm: 'He doesn't know the neighbourhood, he'll get lost in the crowd!'

Gary tells me not to move. I watch him stride off confidently and I feel less afraid. If anyone can ferret out a runaway boy, it is definitely this man whose bearing and build are so reassuring.

But the weather is beginning to turn cold. It seems as if all the children have conspired to wear a blue anorak just like my son's. I am suddenly very weary. Angry too, at the thought of spending the rest of the afternoon standing there in the wind, which is no longer a light spring breeze. Angry at having my day ruined.

Éléonore leaned towards me, her eyes shining with emotion.

'Something tells me that wasn't true! Your day wasn't ruined – far from it!'

'You guessed right. They were soon back. Gary, pipe still in his mouth, with my son sitting on his shoulders and waving happily at me.'

'How beautiful!' Éléonore exclaims.

Happy and proud, I continue my story:

'Gary was smiling a broad paternal smile. He waited until he was by my side to say: "Everything's okay. I knew I'd find him in front of the shooting range. Boys of his age love it." He lowered my son down onto the ground, gave him a little pat on the head, took his arm and announced: "Let's go and have a cup of tea! Your mother's freezing. Then we'll go home."'

Éléonore, her eyes half-closed, enunciates her words to underline her excitement.

'I really like the sound of this man!'

'Once home, I made pancakes for us all. Gary was watching me and suddenly he leapt out of his chair like a jumping jack and blurted out: "Let's get married!" He kissed me, kissed my son, and then said: "I'll find us a big apartment. My salary will be enough. This boy will go to a good school. And you will play music, you'll write, you'll organise teas for my students, you'll pour them tea, you'll enjoy that, won't you, inviting my students to tea at our place? I'll help you shop, we'll buy fruit, vegetables and lots of pot plants for the apartment."'

I imitate the way my newly acquired fiancé made his proposal and then I burst out laughing.

'My pancakes were good, but even so, don't you find it odd that he was proposing marriage so soon? I didn't ask anything of him!'

Éléonore doesn't laugh. She shakes her head.

'Why shouldn't he propose marriage? That's what

he's looking for. That's what you want. This man is logical, it's as simple as that. He's a mathematician, remember.'

Éléonore, her hands full of biscuits or fruit, tartlets or tubs of cream, Éléonore flinging her raincoat despairingly onto the mattress that serves as my bed, throwing herself onto it, taking out her cigarettes and announcing:

'Antoine and I spent the whole night tearing each other apart. I'm totally knackered. But let's get on.'

Our work progresses slowly, with constant interruptions. From me, most of the time.

'What amazes me is that I took it all seriously.'

'Love's a serious business. Antoine knows he holds my life in his hands.'

Her huge grey-green eyes are suddenly brimming with tears.

'Have faith. I believe in this man of yours.'

'But he didn't even phone me from the airport, didn't give me a quick call when he arrived to reassure me and tell me that it wasn't all a dream.'

'You're asking this man to love you as others have loved you, following the pattern you're used to. This time you're dealing with a man who's calm, sure of himself and of your future together. You're so lucky! This man exudes peace of mind. What more do you want?'

'Nothing, you're right. I'll have a house filled with the warm, comforting smell of a man with an affectionate smile and broad shoulders. My son will have a father who'll help him with his maths.'

I tell my friends about the pancake episode. I put on a tone of delighted surprise although not without irony, but still I feel slightly ridiculous.

'It was while he was watching me toss pancakes that he suggested, point-blank: "Let's get married!"'

I don't want to show what I feel deep down, disclose my fervent, crazy hope. I don't want to admit that as I listened to Gary set out what I laughingly call his agenda, I could hear my mother's voice: 'Don't make a noise, children, Professor X has come a long way to work with your father. Come and help me prepare the tea tray.' I could see my mother, the smiling, welcoming mistress of the house, confident in herself and in her role as the famous professor's wife.

I don't want anyone to know how appealing I find this agenda. I'm annoyed with the friends who shrug or pull a face before replying: 'It's all a bit dodgy, a bit flimsy, isn't it?'

I prefer the earnest tone of Éléonore, who believes in these things, and her serious expression when she says the words 'dependable and kind' like an incantation that evokes the absent Gary, conjuring him up in the room where he suddenly fills all the space,

armed with those two qualities that promise happiness: dependability and kindness. Éléonore's voice has that power.

The days go by, the prophets file past, Jonah in his whale, Ezekiel and his wheels, and Éléonore and I embroider my love story. Now it's more than a week since Gary left. Staring at a blueberry tartlet I'm about to bite into, I ask:

'How long does a letter take to get from New York to Paris? Five days? Six?'

Éléonore, wearing a bell-shaped skirt or a grey flannel outfit that makes her look like a nun, either in trainers or perched on perilously high heels . . . Of Éléonore, who is different every day, I always ask the same question:

'Do you think a man can love a woman he has only known for three days?'

Éléonore firmly believes he can. Her tone is severe.

'What do you expect? He's not a literary type, he's not going to swamp you with insincere poetic epistles. Think of the beautiful love letters written by the most cynical of writers, who didn't feel a word of what they set down so lyrically on paper.'

On the day of the postcard, Éléonore arrives exhausted, dark circles under her eyes, wearing a dress so tight that she can barely walk.

'This morning, we had a row and Antoine walked

out slamming the door. I haven't been able to get hold of him. I feel that something very bad is happening.'

'But in the two years you've been together . . .'

Éléonore stops me:

'You don't understand. He loves me, of course he does, but he has an erratic nature. An artistic temperament. But for me it's different – he means more to me than my own life.'

She slumps down onto the mattress, rests her head on a cushion and looks as if she's about to pass out, but she perks up when I hold out the postcard from Gary, which she examines closely. Then she looks up at me, without letting go of the card.

'I definitely like this man more and more.'

'It's a bit curt, isn't it? Best wishes? And why not regards?'

Éléonore shakes her head. A wisp of fair hair escapes from her chignon.

'He's a mathematician, not a novelist. What do you want from him?'

'My father's a mathematician, and he used to send my mother poems.'

'That was a different generation.'

Éléonore is a handwriting expert in her spare time. From the way Gary forms his capital letters, she can see his high degree of sensitivity as well as the decisiveness so desirable in a man.

'Look at the firmness of his writing, the absence of unnecessary flourishes. Believe me, there's something extremely reassuring about it.'

Her eyes glued to the postcard, she concludes with emotion:

'This man loves you. He doesn't waste his time with platitudes.'

Three days later, the plane ticket arrives. Éléonore is jubilant.

'You'll see, he'll prove to be the rock-solid man you're looking for. You're used to passionate declarations of love, but those men are unreliable,' she announces gravely, offering me a generous slice of tart.

And now, the dependable, kind man and I are sitting in an elegant Italian restaurant in Manhattan. We came by taxi because it was raining. 'We don't want you catching a cold on your first evening. That won't do, will it?' he said affectionately as he bundled me into the car. During the drive, he kept saying that he wanted me, there and then, in the taxi. I laughed, thrilled, giddy. I forgot my disappointment that he hadn't come to meet me at the airport but had waited for me at home, his head buried in his papers.

The moment we entered the restaurant, the maître d' and the waiters rushed over to us: '*Professore* . . . *Signora.*' We were shown to a good table. Gary must

be a regular. I imagined myself as a pampered wife, the centre of attention, you mustn't catch cold, taxi, *Signora*, table reservation.

The maître d' himself poured the Vino Nobile di Montepulciano into the large, round glasses. We drank to our life together. And immediately afterwards:

'You wouldn't have in your bag something you could read? I'm sure you always carry a good book with you.' I'm taken aback. He must be joking. I smile. The uncertain smile of someone who doesn't understand but wants to give the impression she does. But no, he's not joking.

'Read for a while, I have to work.'

He has already taken out a yellow notepad and a pencil from his jacket pocket, and, ignoring me completely, he's scribbling columns of numbers. I watch his face poring over the paper. His forehead, wider than it is high, his chestnut hair. On reflection, nothing especially remarkable. He takes the occasional sip of wine, without looking up. Attempting to appear composed, I cup my glass in both hands.

In my head I can hear Éléonore's voice, her deep, earnest tone: *You dare to complain? Look how he takes care of you, how attentive he is. You're part of the life of a man who has enough confidence in you, in your relationship, to take out his work while you're having dinner. That's really beautiful, you know.*

Silently, for Éléonore's benefit, I moan: 'You think that's beautiful? He hasn't seen me for a month, I've just arrived and I'm here for four days! He could talk to me! Look at me!' Éléonore doesn't back down one jot: *I think it's not only beautiful, but admirable. You are so much part of this man's life that the weeks of being apart are as nothing, they don't count. He doesn't think of them. You're there, you're together, that's all. It's so simple!*

I take a sip of wine and look around me. The maître d' smiles at me across the room with a look that is both respectful and knowing. I return his smile. I feel better. I tell myself that I'm on the verge of getting involved, perhaps for life, with a distinguished mathematician. He's preoccupied with his problem. So be it. In other words, that's part of who he is. *Professore.* He paid for my flight to have the pleasure of spending a few days with me. I'm sitting in a classy restaurant. And yet, this moment of rebellion, like a tidal wave, almost knocked me off balance and has disconcerted me.

It's the jet lag, tiredness, whispers Éléonore's lovely voice. *Ignore it, this man exudes peace of mind.* Gary finally looks up and smiles.

'You're here, our food is on its way and the pianist has just arrived, a Yugoslav who plays brilliantly. Life is beautiful!'

We are served grilled artichokes, mushrooms. Everything is exquisite, very subtle. My companion

has put down his notepad. I ask:

'Is it still the same problem? The one you were working on in Paris?'

'Yes. It's going to take me several more months. When I've finished, I'll go apartment hunting for us.'

He smiles and urges me to eat before the food gets cold. He eats unhurriedly, pours the wine, then gazes at me attentively.

'Tell me how your son is.'

'I'm worried about him. He's not good at arithmetic. How ironic! The grandson of a famous mathematician!'

'It's a matter of maturity. I'll work with him. Don't worry.'

Gary flashes me his warm smile. The Yugoslav pianist launches into a Mozart sonata. I find he's too heavy on the pedal. But Gary has taken my hand.

'Listen how well he plays.'

He closes his eyes and follows the music, gently nodding his head. The pianist begins the last movement. Still too heavy on the pedal. He makes what is clear sound cloudy, and what should be limpid, muddy. Gary opens his eyes again, fills our glasses and declares:

'I'd like to help that pianist. He's a refugee, his life must be hard.'

I feel no sympathy for the young pianist. Being a refugee is no excuse for being too heavy on the pedal when you're playing Mozart.

Gary applauds enthusiastically, yelling 'Bravo!' The pianist stands up and walks over to our table. I suddenly have the impression that he's holding out a big, invisible hat with which he's going to sweep the floor in a deep bow. I can't help noticing that this obsequiousness does not displease Gary, nor does the invisible hat held out towards him for him to throw dollar bills into. He clasps the young man's hands, congratulates him again, and only lets go to give him his telephone number: he's going to help him, take care of him. He asks:

'Is your violinist friend not here this evening?'

When the pianist finally leaves, all smiles and with the telephone number in his pocket, Gary tells me that the young woman violinist is Indonesian, also a refugee.

'She's bound to need friends, money. We'll invite her to our house, we'll offer her a room.'

'But you don't know her!'

'So what? Don't think that once I'm married to you I'll stop taking an interest in the rest of humanity. It's because people are selfish that the world is in a mess.'

He holds forth at length on this theme which appears to be dear to him. As I savour my tiramisu, which is delicious, as was the dinner, I try not to admit to myself that I'm bored. Dessert finished, I place my hand on Gary's arm. We're going back to

the apartment to be together, forget the pianist and the violinist.

'Are you happy I'm here?'

'Yes, very happy. I'll miss you, but you'll be back, we'll rent a big apartment and everything will be fine.'

'Will you write to me this time?'

'You're the writer. But if you write to me, I'll write back.'

He smiles his calm, warm smile and drinks some wine. His hand on mine is broad and firm.

'Don't worry, I'll love you very much. Everything will be okay.'

Everything will be okay. Yesterday, from Paris, I phoned New York to confirm my arrival. One of Gary's students answered. A few hours later, I called back. The same student replied that Gary had asked him to tell me that everything was okay. Éléonore overheard the phone call, thrilled.

'This man's extraordinary. He's so sure of himself and of his feelings. He's so laid back! So restrained! He loves you, he's waiting for you, why should he make passionate declarations over the telephone?'

That evening, I was having dinner with friends, the ones who from the start had found all this a bit dodgy, a bit flimsy. Emboldened by Éléonore's words, I defended Gary. 'There's something so simple, so

calm in his way of not according any importance to that phone call, as if our relationship were so evident that he sees no harm in leaving his student to give me a message.' I'd spoken in an imitation of Éléonore's deep, earnest voice.

On leaving the restaurant, Gary bundles me into another taxi. It takes me a few minutes to realise we're going the wrong way.

'Aren't we going home?'

'It's not even midnight. No one will be able to say I didn't show you a good time in New York.'

'But I've come to see you, not to go out.'

'See me, go out, it's all the same. I hate people who shut themselves up in their narrow little family life. And besides, next year, your son will be with us, and I'd never have the heart to leave him on his own. So let's make the most of it.'

The bar is big, garishly lit, almost empty. The barman is drying glasses. The handful of custom-ers, visibly regulars, are gathered around the piano. They put their drinks and empty glasses on the lid. I perch on a high stool. At the piano is a black guy with greying hair, his features puffy with exhaustion in the harsh light. Gary tucks a large-denomination bill in his pocket and asks him to play 'something spe-cial, because tonight my fiancée's with me. She's from

Paris'. A woman begins to sing. She's well into her forties, skinny and heavily made-up. She has the smile of a woman who's been through the mill and understands human weaknesses.

'She's wonderful. She spends every evening here,' whispers Gary.

I wonder to what depths of loneliness you have to sink to spend your nights drinking beer and singing blues in front of a bunch of equally sad and lonely characters.

A very erect old man, with white hair in a crew cut, whose shoulders are still powerful beneath his checked flannel shirt, has come to sit beside me. He rests his elbows on the piano and gazes at me with startlingly blue eyes. His face is lined with wrinkles.

'I was in France in '44. Paris, the Champs-Élysées! The pretty girls! Hey, talk to me, say something nice in French!'

Gary has downed his whisky in one. He orders another. He puts his arm around my shoulders.

'I'll cry real tears after you leave. Don't go. Phone some friends and ask them to look after your son. Stay here. No, don't. You're better off in Paris. Listen, listen to this woman, how she sings.'

She does sing well, and with all her heart. A slightly metallic voice, fragile. I imagine a woman betrayed, abandoned, who preserves herself like this, with her

delicate, careworn face, her unfashionable make-up, her too-red lips, living in a sort of time warp. While she sings, the former GI sips his beer and continues to reel off his memories of the Liberation of Paris. When the woman's blues number finally ends, Gary takes her in his arms and kisses her at length on the lips.

I think: 'Éléonore, Éléonore, what would you have to say about my kind, dependable fiancé right now? I'd really like to know!'

The singer has sat down next to me. She smiles, and her smile says none of this means anything. She smiles as if I'm a younger sister who knows nothing of the world as she does. I tug at Gary's sleeve.

'Let's go.'

'Yes, yes, wait a bit.'

The singer has placed a hand on my shoulder. 'A man doesn't allow himself to be dragged away when his glass is still full. Haven't you learnt that? Well now's the time to learn it.'

I don't want any more lessons from the singer with the faded looks. I'm not playing any more. I wonder what time the Air France agency opens.

We'll take another taxi. We'll drive almost the entire length of Manhattan, its streets lit up but empty. Perhaps Gary will tell me I'm beautiful and wonderful, that he's going to marry me, that he'll raise my son, that everything will be okay in the big apartment

he'll find as soon as he's resolved his maths problem. Then he'll sleep. I'll watch the dawn break over the red bricks of Harlem. I'll fasten my suitcase and put water in the kettle to boil. I'll hastily drink a cup of Nescafé, sparing a brief thought for the students for whom I'll never pour tea.

Self-portrait as a visitor

I am particularly fond of Olga Boznańska's self-portrait, painted in 1909. She sits bolt upright, facing us. A few splashes of a lovely orangey-red suggest that she is holding some flowers. A lady on a visit. You are struck by the thin face emerging from a very high, black, austere collar, her complexion pale but not sickly. Her dark chestnut hair is pinned up, but not scraped back, in a bun hidden under an extraordinary hat – a sort of Chinese hat, amusing but elegant. Its top is not visible, but it is probably pointed. Comprising several layers of colour, it is perched so high on her head that it seems almost to float above her hair, but you sense that the angle of the tilt is stable and perfectly controlled. That hat will not budge! Her eyes are quite small but very dark, and her slightly haughty gaze is not directed at the viewer. It is a distant, ironical gaze that asks nothing of anyone. Thin lips, a tentative, indefinable, almost secret smile, undeniably mocking but devoid of malice. It is the portrait of a person who is perfectly in command of the situation. What situation? The painting does not say.

I like the idea of painting myself sitting in a Louis XVI-style armchair in a bourgeois drawing room. Behind me dark-green velvet curtains can be glimpsed, and half of a loveseat upholstered in a floral fabric matching that of the armchair. Flaming gladioli shoot up from a bronze vase standing on the floor. I am wearing a rather severe suit in a lovely marron glacé shade, bought shortly after my mother's death. That dates this portrait: it is 1986. I am sitting up straight; in one hand I am holding a saucer and in the other a delicately painted, translucent bone china cup. I am pretty; my black hair is quite short, a cut that is both expert and natural, the work of a skilful hairdresser able to tame my wayward, frizzy hair. My eyes are ringed by huge glasses with a red frame that was in fashion that year, I believe. Thrusting my head forward a little, I give a faint smile that is both affectionate and knowing and seems to be directed both at the contents of the cup and at an invisible person – a woman (it seems unthinkable that it should be a man).

*

The maid has just brought in the tea tray. The tea gives off a faint smell of woodsmoke. I recognise an English blend whose slightly bitter flavour my mother liked, the taste of dead leaves. She would sip it slowly,

dreaming of a calm life, of peaceful interiors. 'I was made to live in the country,' she used to say to her children. 'Yes, the English countryside, that's what would have suited me. And never to have to move home,' she'd sigh. Together, we'd imagine the ritual of tea served by women whose clothes the colour of heather and sage evoked the moors. We pictured wainscotted rooms with armchairs that had never known any disturbance greater than being shunted closer to the hearth on winter evenings.

'If you knew how much pleasure your visit gives me. I don't need to tell you how grieved I was at the death of your dear mother. Whenever she came back to France, we would spend a few delightful hours together. And I assure you that being respectable grandmothers did not stop us from giggling like schoolgirls.'

And there is something childlike about her round, still-fresh face leaning towards me, perhaps because of the dimples created by her constant cheerfulness.

'Your telephone call yesterday reminded me of hers, every year in the spring. Her clear voice. I recognised her the minute she opened her mouth. My swallow!'

I drink her words. Later, I'll give her the photo. I'd glued it onto a cardboard backing that made a frame around it and put it into an elegant envelope on which I wrote the name of my mother's best friend. I chose as my gift to her an image that I felt was typical of

her and full of life: my mother sitting on the edge of her bed, pushing down with both hands, about to get up. Behind the bed, on a chest of drawers is an assortment of objects: the little sewing basket in the shape of a duck, the Indochinese mirror inlaid with mother-of-pearl, a cuddly toy monkey, a Mexican as high as a hand, several Japanese kokeshi dolls with nodding heads – objects so familiar that each one of them feels like an extension of her. The expression on her face is happy but there is something fragile about it – the pinched corners of her mouth, the barely noticeable widening of her over-watchful eyes. I remember my mother's gestures as she took off her apron, smoothed her hair and patted the multicoloured Indian bedspread. Her slightly breathless laugh: 'You're not going to photograph me looking like a slattern!'

'I can still see her sitting there, exactly where you are, so elegant in one of those pretty suits she'd have made when she was passing through Paris.'

The visit to the lifelong friend, solemnly announced early in the morning. My sister and I watched my mother get ready. She put on a slate-grey houndstooth wool suit with a nipped-in waist for the occasion. It was as if she were donning armour or a coat of mail, making us imagine that this visit to the best friend was some sort of joust.

So, it took place here, against the discreet tick-tock

of the clock presiding on the mantelpiece in this room where everything matches and is coordinated, where the Louis XVI armchairs upholstered in a thick fabric with an intricate leaf pattern, the rugs with muted colours, the precious-wood writing desk and the parchment-finish lampshades create an overall effect that is so harmonious, it is hard to imagine a single line being disturbed. I say:

'You who were so close to Mama.'

The friend replies with a smile:

'What made this long friendship so special, you see, was that we had no secrets from each other.'

Below, in the street blocked out by the heavy velvet curtains, the cars drive over the rain-soaked tarmac, at times filling the drawing room with a dampened murmur, distant and yet intimate, almost loving.

I feel like giving in to a sudden urge to behave like a child. I want to remove my boots and tuck my feet under my long woollen skirt to warm them. And declare that I hate tea and would rather have a hot chocolate.

The friend would smile fondly: 'But of course, we'll make one for you right away.'

She is barely taller than my mother had been, but is more solidly built. Her hair colour is the same, that blond shade worn by women who put off turning white, and she too has creased eyelids and delicate, slightly tired skin. The friend's flesh is still supple and firm. I

can't take my eyes off her rosy face with its features so beautifully defined. Perhaps it will make me forget the other face, the one that haunts my dreams, a face once so familiar, so close, and whose now vague features unfold and float, hovering close and then drifting away, without ever vanishing altogether.

The friend's eyes light up, shine.

'Just think how many years have passed since your mother and I used to walk up Rue Gay-Lussac together.'

I too lean forward. Hanging on every word, holding my breath. Yes, that's it, that route and not another. Boulevard Saint-Michel, Rue Gay-Lussac. When you walked up the street with my mother, that child I only ever meet randomly on the faded pages of a photo album miraculously salvaged, that thin face devoured by enormous eyes, always with a flicker of some anxiety or other. When the pair of you walked up the street. I want to hug this lady whom I barely know and who, suddenly, feels closer to me than any other being in the world. She calmly recounts:

'We had no end of fun, we never stopped laughing. We were young, what can I say? The slightest thing would have us in fits of giggles.'

I stretch out my legs and shift to a more comfortable position. I am certain that the friend's reminiscences will create an enduring bond between us. It will be a

story told in two voices. We will evoke the hysterical laughter of two mischievous schoolgirls in a Parisian lycée, more than half a century ago, the quirks of a teacher they never tired of mimicking, the boy they passed every day on the way to school and whom they'd nicknamed *Ça gaze* – speedy – the lovelorn glances he darted their way, the words they made up, their secret code.

Because in the evenings, after dinner, in cramped kitchens, on one continent or another, through a series of exiles and house moves, my mother tirelessly wove for her daughters the tales and legends of her youth, imprinting forever on us, like a fixed point in a changing world, nostalgia for a childhood that was not ours.

Everything was rosy in the childhood she painted. Our grandmother, a primary-school teacher and war widow, had refused to be separated from her children who, as the orphans of an officer father, would have been entitled to a place at the best boarding schools. But they had never lacked for the necessities. Life with their mother had been beautiful and happy.

But was there already apprehension, anxiety, in the clear gaze of the schoolgirl who would one day become my mother? That for me was the real question, the one that has been tormenting me for a long time, the question I have to ask the childhood friend. She will look at me as if for the first time and exclaim: 'Did you sense

that? You really are your mother's daughter!' And I will say to myself that no one in the world knows me like this woman with limpid eyes, ringed with creases so delicate that they are barely wrinkles but rather tiny signs of vulnerability, promises of kindness.

Then will come the moment to ask for the advice I need. The way a daughter asks her mother for counsel. The friend will say authoritatively: 'My child, this is what you'll reply to those people, this is what to do.' I'll listen like a meek little girl being lectured.

Then, numbed, almost sleepy, I'll announce that I'm tired and would like to lie down. The friend will find that wish natural. I'll be shown into a quiet, cramped bedroom overlooking the courtyard and almost entirely taken up by a huge bed. I'll snuggle under the eiderdown as high as a mountain and bury my head in piles of pillows and bolsters. The sounds of the day will reach me from far, far away. I'll fall asleep. When I wake up, the mistress of the house will say: 'You'll stay for dinner, won't you, darling, you know this is your home.'

Maybe I did actually doze off, my chin cupped in my hand. It suddenly feels as if the room is filled with words settling in the drawing room, very much at ease because they're regulars, they're at home, clinging to the curtains, perched on the mantelpiece, on the backs of the armchairs: house, husband, pride, success.

'Your father, the brilliant mathematician whom I felt I knew so well, even though I only met him twice, and briefly at that – an outstanding mind – and then the marvellous post he obtained over there. Yes, my beloved friend could be proud of having made a very good marriage.'

Good marriage, marvellous post. And the friend's plump fingers on the teapot handle, and the amber-coloured tea in the fine porcelain.

In the depths of my bag, there's another photo still in the Kodak wallet. This photo, which my mother used to call the 'official photo', shows her in three-quarter view, sitting on a handsome dark-tweed couch of a streamlined Scandinavian design. She's wearing a pearl-grey silk blouse. Her left arm draped along the back of the couch and her slightly wistful yet affected smile give the impression of a peaceful, conventional happiness, not lacking a certain sensuality.

The friend asks:

'She entertained a lot, didn't she? Cocktail parties, as they call them over there?'

I immediately hear my mother's voice, laughing and at the same time anxious: '*Mon Dieu!* All those people are going to be here, tall people with their topics of conversation that your father finds so interesting. You'll see, they'll lean towards me like giraffes stunned to discover a little creature from another species that

has suddenly appeared in the midst of their herd.'

'One day, your mother showed me photos taken in her house, during one of those receptions she was giving.'

'"Reception" is a rather grand word.'

The photos of my mother from over there, from a country where she never stopped feeling like an outsider. Her smile hesitant, sometimes distorted by the effort she had to make to pronounce words that did not come naturally to her, sounds for which she was ill-equipped. 'Look at this, how hideous! The dreadful face I'm making! I look like a dolled-up macaque.'

Did she show her friend the 'photo of the macaque'? Did they laugh, laugh themselves silly, splayed in the Louis XVI armchairs, as limp as two rag dolls, gasping, crying with laughter, blowing their noses and wiping their cheeks, finally getting their breath back then, their eyes misty, sighing with one voice: 'Ooh, that feels good!'

'They were very pretty photos, so I could admire the house your parents ended up building over there, in Princeton, a house that was so elegant, so beautifully designed. I imagine she brought back fabulous objects from her travels, works of art.'

I have to restrain myself from bursting out laughing. Neither fabulous objects nor works of art, but dolls with no arms or legs, birds and monkeys carved from

wood, tiny cuddly animals which she carted with her from one continent to another, from one uprooting to another.

The friend hasn't noticed anything.

'And your mother, stunning, elegant, remaining French down to her fingertips, while making herself perfectly at home everywhere and in every situation.'

'She'd complain, sometimes bitterly, that she'd been born under the sign of the suitcase.'

The friend smiles, a relaxed, calm smile.

'That was a joke. Your mother loved travelling.'

But the ships, she must know about them. Even if they didn't share that fate, even if the friend didn't have to flee from the land where she was born, hadn't experienced the steamers crammed to overflowing with wretched or desperate refugees, surely they talked about the painful exile, which later became permanent, the constant homesickness, and goodbyes repeated over and over on station platforms and airfields or in hotel rooms in the early hours?

'And the wonderful tales your mother brought back from her travels. She had a gift for storytelling, for making you see things. It was enthralling.'

That immigrant look they had never managed to shed and which made their children ashamed: my father's beret, my mother's headscarf and her forced smile, her features tense with anxiety, and her tears and

47

apologetic explanations to the children she dragged around with her, or left behind, entrusted to the care of others: 'Please understand, I have to follow your father, we have no choice.'

I can't help blurting out:

'But all those departures, the separations. For us children, it was so hard. It left us with so many scars.'

I spoke too loudly. The velvet curtains were shaken. The lamps shuddered. In the fat bronze vase by the fireplace, the gladioli appeared to wither. The friend's answer sounds like a reprimand despite the rather too-pleasant smile that accompanies it.

'A rich and varied upbringing that has borne its fruits. Your mother always used to speak proudly of her daughters and her son, of their talents, their successes in their respective fields.'

Talent, success . . . the gentle, comforting warmth of the cup in the palm of my hand. If I squeeze it a little too hard, the cup will break, the tea will spurt between my fingers and spill over the rug.

The friend looks weary now. Her smile has faded and her gaze rests disapprovingly on my legs. I hastily bring them back towards me and sit up in my chair. I mutter that it's late, that I'm going to leave. The friend does not protest.

'You're not like your mother. I can picture the plaits she had as a child, and later the braids framing her face

under her hat. You're too young, you don't remember the charming little hats she wore.'

Yes, I do remember. I see her forget-me-not-blue eyes, her delicate eyelids, dark eyelashes, slightly separate, like doll's eyelashes, and the light shadow cast over her forehead and nose by the gauzy, midnight-blue veil. But then, I can't help seeing my mother's face crumple the way it did when it was time to say goodbye, as it disintegrates now, yellowed or grey, on the identity documents, visas and permits to enter, cross a border, reside or exit. I say, as if it were a matter of utmost seriousness, on which the friend owes me explanations which she alone can offer:

'Mama always remembered the hat she was wearing on the day war was declared.'

'That doesn't surprise me. She had a milliner friend who designed beautiful hats for her.'

But she's hatless in the photograph she'd had taken of herself in Marseille, before setting sail. Before fleeing her native land, perhaps forever. Years later, living at my grandmother's, I fell asleep every night under the abnormally luminous gaze of that young woman whose smile, though gracious, was frozen with sadness.

'Yes. Her milliner friend. When my mother came back to France, she looked for her in vain. We never found out what became of her.'

We stay silent. Outside, darkness must have fallen, but it is impossible to tell. The thickness of the curtains and soft lights give the room a funereal atmosphere.

It is the friend who breaks the silence:

'You know, I think she enjoyed the travelling, the moves. She was remarkably efficient. Like a diplomat's wife. She had to be, with your father's position.'

She is offering me a helping hand. It is up to me to grasp it. I reply:

'My mother had a sense of humour.'

'Your mother was *joie de vivre*, cheerfulness, person-ified.'

The miracle happened. The friend is rosy-cheeked and dimpled once more. She's no longer tired. The lamps – good fairies – promise peace and security. The gladioli dance for joy in their vase.

Then, like a priceless gift which I'm proud to offer my mother's childhood friend, I tell her one of the most beautiful of my own childhood memories: one grey, wet afternoon in a far-off town we were about to leave, my mother stood in the doorway holding a huge package: 'Look what I've just bought!'. I describe how we hast-ily pushed the few items of furniture back against the walls, the suitcases piled higgledy-piggledy and the unforgettable game of skittles in a succession of empty connecting rooms.

'She'd bought a game of skittles?'

'A magnificent game of skittles which we abandoned the next day when we left.'

'Well, that's original, at least.'

Silence once more. The rain has stopped beating against the window panes. The maid has removed the tray. My hostess rises.

'It's stopped raining. But you have no need to worry, with your boots.'

Something in her tone of voice immediately makes me regret wearing those boots and having opted for a long black flared skirt and a brightly coloured sweater. I suddenly say to myself I'm going to buy a suit. I should have tied my hair back in a ponytail. Or accepted the invitation of a friend who wanted to take me to have my hair done at Carita's. The crazy notion occurs to me that I should perhaps have worn a hat.

Before getting up, I rummage in my bag and take out the Kodak wallet that contains the 'official photo'. I hold it out to my mother's childhood friend, apologizing for not having had time to put it in a more elegant envelope.

Self-portrait with portrait of my son

In 1715, Rosalba Carriera depicted herself painting a portrait of her sister. She balances the portrait on her knees, supporting it with her left hand. In her right hand, she holds her brush. The sister, seen in three-quarter view, resembles her so closely that the painting looks like a self-portrait: the same elongated, wide-set eyes, the same skin and hair colour, the same ringlets on the forehead. The artist is sumptuously dressed, with silks draped around her shoulders and lace around her décolletage and at her wrists, and a big silk flower in her hair. She portrays herself as a serious person. Her faint smile is strained, and the expression in her eyes is a little sad. The sister, by contrast, has a rather smug smile. She is prettier, probably vainer, than Rosalba. Is she an adored, absent younger sister whom Rosalba is pining for? Will the double portrait be a gift? Is it a peace offering after a quarrel? The artist is not looking at her work. She is looking at us. What is Rosalba thinking about as she puts the finishing touches to the somewhat mawkish, slightly-too-pretty portrait of her sister?

I paint myself sitting in a car, in the passenger seat. The viewer would see me through the windscreen. I'm wearing a light, silky, grey dress with a dark-blue pattern – quite subdued colours for summer. It's unusually low-cut for me and tight-fitting over my bust. I'm holding a camera, on whose screen appears the face of a bearded young man with chestnut hair and almost-black eyes. The screen is small but you can see that the young man is good-looking. I'm holding the camera up a little and to one side, so that I can look at the screen while shielding it from the glare that would blot out the image. My eyes are turned towards the camera and I'm smiling. An indefinable smile, both tired and contented, without real joy, but triumphant.

*

Sitting around a table for hours in a nondescript garden, making small talk and eating too much, is what's called spending a Sunday *en famille*.

In the past, on summer Sundays in our village in the Sarthe, lunch sometimes went on for hours. When we couldn't sit still any longer, my sister, my cousins and I would leave the table. I'd rest my elbows on the lower half of the door, lean out of the open top half, my face turned to the sun, and listen to the sounds behind me of cutlery clattering against the plates, of

glasses being filled. My grandmother would declare, as if announcing an extraordinary piece of news, 'I bought an apricot tart.' All the windows were open and from all the kitchens in the village came snatches of the same peaceful sounds, mingling and merging, filling the narrow streets and small gardens, lending a comforting texture to the silence of the day of rest: the rugged, slightly heated voices of the men when they clinked glasses, the tinkle of the glasses knocking together, the scraping of saucepans on stoves, the rattle of plates being piled up in the stone sinks, and also the voices of the women, bustling around and laughing: 'You'll have some more of my semolina pudding, won't you?'

New Jersey is not the French countryside, obviously. Paper plates and pale-blue plastic cutlery are silent.

On the other hand, three pesky little dogs chase each other under the table, yapping shrilly. When they come close to me, I clap my hands over my ears to protect my aching eardrums, taking care to laugh, as if to say yes, of course, I'm the one who's ridiculous to have such sensitive ears. I wouldn't want to upset my son for anything in the world. He and his wife don't have any children, but they do have the dogs. He's very fond of them.

I tell myself we're a normal family, we have normal activities. I try to find that satisfying, somehow.

I behave like a good mother-in-law, like a normal mother-in-law. I do all the right things. I've brought two roast chickens, and the ingredients for a salad. And also a bottle of wine. My daughter-in-law is happy to see her parents-in-law sitting at her table. She's cooked fish skewers for us under the grill. All the same, she says we're wrong, Eric and I, never to eat meat, that the body needs red meat, she knows what she's talking about, she's studied nutrition. She sends my son to fetch the stemmed glasses, a wedding present.

'For the wine your mother brought, honey. We're not going to make her drink her Bordeaux out of a plastic glass!'

I feel duty-bound to entertain my son's mother-in-law. It is Sunday, I am at her place, in her garden, the least I can do is to be cheerful and crack silly jokes. For instance, when she congratulates me on the quality of my chickens:

'Me, roast chickens? You've got to be kidding! I bought them ready-cooked. At our age, we've done enough slaving in the kitchen, haven't we, Josefina?'

Josefina's laugh is more of a guffaw. She retorts: 'You're too much! Always saying something funny!' Her daughter adds: 'It's true, my mom-in-law loves to joke!'

I imagine the thousands, no, the millions of people who spend their Sunday this way. *En famille*. Sometimes they argue, it's well-known: political differences,

jealousy, personal acrimonies. Then the lunch ends badly. The men shout, the women cry. But we have no reason to argue, we talk about nothing, and above all not about the fact that my son looks pale, that he is visibly exhausted, and that he doesn't have a corner or a drawer to call his own in this vast, dilapidated and dusty house where he lives with an entire tribe. A house that's two hours away from his workplace.

I have to stop myself from thinking about it, forget that I nearly broke my leg because the front steps are rickety and that it's a serious hazard for my son who limps and easily loses his balance. Forget, don't think about things that are painful, it's Sunday today, the sun's shining, let's drink some wine.

Eric has finished eating. He's opened a book. My son exclaims in an aggrieved tone:

'Ha! Now Eric's getting his book out! Our conversation doesn't interest him.'

My husband looks up and gazes around him frowning.

'It's okay, I was kidding,' my son goes on. 'As long as the earth keeps spinning, my parents will have their noses buried in their books.'

I protest, laughing:

'Not me, not today, I'd like to point out! In any case it runs in the family, as you well know. Remember your grandfather!'

My son laughs. He explains to his in-laws:

'My grandfather would bolt his food down then he'd leave the table and go and sit in an armchair to read. We were used to it, we thought that was normal.'

He leans over to kiss his wife's bare shoulder. She's beautiful, with huge dark eyes and a radiant smile. That would make a lovely photo. Soon, I'll take out my camera. It's a way of filling the time and it lightens the atmosphere. They'll tease me: 'You and your obsession with taking photos!'

My daughter-in-law's shoulders are broad, brown, plump and very soft. When I arrived, she hugged me. 'You're wearing the dress I gave you, that's nice. You have to admit I know what suits you.' Then she lifted me off the ground. I gave the little shrieks that were expected of me. 'I used to be a professional weightlifter, remember,' she said, with a hearty laugh, before putting me back down on the lino floor of the kitchen. I replied, laughing as well, that I'd find it hard to return the courtesy. She's twice my size. Her mother too. And her pretty, teenaged daughter, Daisy.

I take comforting little sips of my Bordeaux. I feel slightly numbed.

Josefina announces: 'This year, we'll have pears.'

With foodie enthusiasm, I gush: 'I'm putting in my order right now!'

Then I make a disappointed little face, and say

reproachfully: 'Last year I didn't get a single one!'

Supermarket pears are much tastier, but that's not what it's about. This is about family ties. Josefina and I are bound by family ties. I'm her son-in-law's *mom*. So I'm entitled to my share of hard, sour little pears from the pear tree. I feel obliged to sound as if I really want them. And besides, it's a topic of conversation that, in theory, presents no risk.

'No one had any last year. The boys played ball in the garden and knocked all the pears off the tree before they were ripe,' explains Josefina.

'They're a bit old to be throwing their ball into a fruit tree, aren't they?'

I should have kept quiet. My son gives me a prolonged, annoyed look that says: 'Aren't you even capable of having lunch with this family, which is now mine, without making disagreeable comments?'

He's right, of course. I'm not responsible for the upbringing of those two boys. I give my son a slightly exaggerated smile and say: 'I'm sorry, it's the teacher in me.'

He carries on glaring daggers at me, but the conversation has already moved on to something else. To nothing. We eat.

One day when my daughter-in-law and I were looking at knick-knacks in a shop window, she told me that when she was fifteen, she'd had a collection of

little glass animals that she adored. One afternoon, she came home from school to find her cousin playing ball in the sitting room and all her animals smashed. That day she vowed to herself never to collect anything again.

I pictured a charmless apartment in a dreary suburb, the tiny ray of light and joy cast by the elephant, the giraffe and the monkey, and then the splinters of glass glinting feebly on the floor and the fifteen-year-old girl vowing never again to become attached to anything. Then I understood why the wedding photos had never been ordered or printed. My son had married a woman for whom any dream, no matter how tiny, was crushed in advance. No joy deserved to have its memory preserved. That day, I felt immense sympathy for my daughter-in-law. But I worried about my son.

In the early years, before hearing the story of the glass animals, I demanded those photos, as if by right, but I demanded them in the only tone that was acceptable between these in-laws and myself, that of flippancy. I'd say: 'So I won't have a big photo of my son's wedding in a beautiful silver frame on my mantelpiece like everyone else?' My daughter-in-law would burst out laughing. 'On your mantelpiece! You're such a hoot. You don't have a mantelpiece!'

My son gets up from the table and goes into the

house. His wife says, to no one in particular:

'It's the World Cup today. He's for France. Of course. That's where he was born.'

He's for France. Those words make me feel strangely glad. God knows I care nothing about football. But the match – because I too, of course, am interested, am 'for France' – allows me to leave the table and go and spend a moment with my son in what serves as the lounge: a dark room occupied by two tired sofas whose stuffing is escaping through a few gaping wounds, and a giant screen. I understand nothing about football. My son smiles at my stupid questions. That smile is all I wish for. His face relaxes, he explains, he's in his element, he commentates the match for his mother who doesn't have a clue. And I relish those few minutes of complicity with my only son.

When he goes back to the table, his wife serves him his fish skewers. She says:

'Eat, honey, I made them specially for you and your parents. I know what you like and I know you like fish.'

When, at the start of the meal, I said to him that I barely saw him these days, and that made me sad, he shrugged, then replied, but with kindness: 'What can I do about it?' I hastily said: 'It doesn't matter, I have the pleasure of seeing you today.' I ran my hands through his hair, I kissed his neck, in the place I used to kiss him in those long-ago days when he was a delicate,

skinny child. Those days when I attempted to console, to comfort that boy for whom the world seemed to be filled with dangers and mysteries. That boy who, at the age of ten, suffered from loneliness.

Right now, his lips are brushing a smooth, plump, brown shoulder. A loud, laughing voice urges him, honey, to eat his fish. I tell myself he's made a place for himself in a world that is reassuringly straighforward.

The moment has come to get out my camera and start taking photos. That gives me permission to leave the table and move around. I snap the pear tree, then the mother-in-law, sitting solid and upright in her chair, a perfunctory smile lighting up her rather stern features. Back to the pear tree, then the mother-in-law. Close-up of Eric who, engrossed in his book, takes no notice of the three dogs noisily yapping around his legs.

'Look at Eric, he's so funny with his Woody Allen cap! Now there's someone whose films I'll never go and see again. After what he did! Marrying his own adoptive daughter! He should be ashamed!' blurts out my daughter-in-law.

'I used to like his films,' says my son quietly.

I examine his tired, drawn face, the dark circles under his eyes. I'm looking for . . . what exactly am I looking for? A tiny glimmer of revolt? A wish to go to the cinema occasionally to see a film of his choice?

A regret, even fleeting, to know that his tastes, his wishes, are so little taken into consideration?

It's best if I keep taking photos. I start by pointing my camera at the sky where – I announce very loudly – there's a very interesting little cloud. All these manoeuvres enable me to disguise my real – my only – project, which is to photograph my son. I snap him in passing, while the round eye of my camera moves slowly from the pear tree to the mother-in-law, from the prettily shaped cloud to the white plastic swimming pool where the brownish water attracts mosquitoes, from my daughter-in-law who's explaining to me how to cook skewers, because she knows all about skewers, to young Daisy stuffing herself with strawberry ice cream. I photograph my son. Full face. In profile. Full face, I see his eyes that resemble mine. In profile, he looks less tired. I stride across the garden to photograph Josefina's rosebush. I dwell for ages on the three scrawny roses with crumpled petals, of a fairly commonplace red. I take several close-ups which I then show to Josefina. To pull the wool over her eyes. To be able to carry on photographing my son.

When the two adolescents, the throwers of balls into fruit trees, come to join the family group, I do not fail to photograph them. They sport broad grins, revealing very white teeth. The eldest has a tattoo on his right biceps: his mother's name in Gothic lettering in garish

colours. He flexes his muscles. 'My mom wants me to have her name etched in my flesh.' He gives a smug smile.

At present, Eric is at the wheel. And I'm deleting. I do so to my heart's content. I delete the pear tree, the perfectly round cloud looking silly in the middle of an even sillier blue sky, and the three roses that are nothing special. I delete the swimming pool with stagnant water, I delete Josefina with her sombre smile, and the girl pulling a face, her nose smeared with pink ice cream, I delete the nephew with his ghastly, incestuous tattoo. Since the photos don't reproduce the horrible yapping, I keep a photo of my son and his wife laughing and cuddling their dogs. I keep a photo of Eric, wearing his Woody Allen cap.

But most of all, clear and sharp on the little screen of my camera, remain several lovely pictures of my son, captured at the right moment, ironic or serious, smiling, relaxed. These images are my spoils, the fruits of a hard-fought campaign.

Self-portrait as a Chinese mushroom

The first thing that strikes me about the self-portrait painted by Gabriele Münter circa 1909 is the heavy and unbecoming straw hat sitting a little too high on her dark mass of hair. Her eyes are wide open, seemingly in surprise or consternation, as if an alien creature had just entered the artist's field of vision, and they are the same bright blue as the ribbon and flowers on her hat. In photos and in the portrait of her painted by Kandinsky in 1905, she has light-coloured eyes, true, but not that startling blue! It's as if the artist had been captivated by that hat, but once home in front of her mirror, away from the milliner who'd talked her into buying it, she realises she has made a terrible and costly mistake. Her thin lips painted in a heart shape, as was the fashion of the day, express nothing if not a certain restraint. Her hands, more suggested than painted in detail, appear to be clutching at the collar of her dress, and this creates a strange sense of helplessness. At around the same time, Gabriele Münter painted several other more accomplished self-portraits, technically subtler, prob-

ably more interesting from an artistic point of view. What is the appeal of this one that could almost be described as a caricature, where she depicts herself as hesitant, maybe worried, crushed by the ridiculous headgear that looks like a huge cake? I feel I can see, in her round, too-blue eyes, in the precariously balanced hat, the artist's awareness that she is in a situation that is impossible to control: her relationship with Kandinsky or the simple purchase of a hat . . . ?

I'll paint myself sitting in front of a computer, in a café filled with exotic plants. I am carefully dressed, elegantly even. I hope the viewer will notice the way the light plays on the silk of my long, old-rose skirt and black jacket. My head is turned towards this – attentive, I hope – viewer, offering my full face, but my hair and the top of my forehead are concealed by a black canvas hat with a wide, slightly floppy brim. My lips are painted a strong red. But instead of enlivening the picture, this red emphasises the tense set of my mouth, the remains of a smile abruptly cut short, as if by the sudden and unexpected arrival of a dangerous animal. Behind the light-coloured frame of my glasses, my eyes are puzzled, anxious. There is a half-empty glass of sangria on the table, next to the computer keyboard. Standing at a slight remove, two tall, slim young waiters wearing jeans and black tank tops look as if they're about to break into a dance routine.

The email subject line reads 'Chinese mushroom'. Leaning over the screen, my fingers curled around my glass, the word that first catches my eye is 'mushroom', and I smile, I'm about to laugh, and then the word 'Chinese' sinks in and my laughter evaporates.

I am comfortably ensconced in Las Chicas, a trendy Tokyo bar, the haunt of young Japanese and expats who find the relaxed atmosphere a relief from the perpetual bowing and other rigours of Japanese etiquette. The Brazilian waiters sashay between the tables, creating an upbeat vibe. The scene takes place in the days before the widespread use of smartphones or the existence of the iPad, and the bar has several computers for the use of its customers. It's one of the charms and not the least of Las Chicas: you can go online and check your emails in peace, while sipping an excellent sangria. Comfortably ensconced, yes, but imprisoned under my black hat with its floppy brim which I keep having to raise to be able to see properly. My eyes glued to the word 'Chinese', I feel my anger mounting. This is a matter of mistaken identity, negligence, indifference, abandonment. Because under this hat that's crushing me but which comes from an elegant Ginza boutique, I am a Japanese, not a Chinese, mushroom.

I suspect that back there, in Paris, someone who has a gift for words and who's not useless at geography is ridiculing me.

Leaning towards the screen, I can almost hear that first telephone call, a stranger's voice, quite deep for a woman, slightly muffled and very soft, saying: 'I loved your latest book, it's a book that gives hope in today's terrifying world. Your previous novels too, I liked very much, I've been reading you for years . . .'

She offers to interview me for France Culture. I'm flattered, thrilled. Who wouldn't be? My friends congratulate me and tell me that the voice belongs to a journalist and novelist who is well known in Paris literary circles.

Comes the day of our meeting. Now, there's not only the soft, earnest voice, but a thin, sensitive face, supple, silky hair like that of a child, and, above all, beautiful blue, questioning, understanding eyes. The interview goes like a dream, wonderfully intelligent, very flattering. I come out elated. That evening, invited to friends' for dinner, I'm subjected to a full interrogation.

'What did she give you?'

'What should she have given me?'

'Names of women's magazine critics to start with. She knows everyone who's anyone in Paris, she *adores* your book . . . what's she going to do for you? Nothing, right?'

I laughed. It was obvious to me they were just jealous, especially the women.

The sequel could be called 'Honeymoon'. Tea at the café in the Luxembourg Gardens, the eyes sparkling with glitter and filled with sincerity, and the owner of those sparkling eyes and the lovely soft voice telling me she's thrilled by this new friendship but she feels slightly intimidated.

And after tea, what could be more natural on a sunny autumn day than to go striding along the paths strewn with leaves and exuding a damp, musty smell, just as we once did as schoolgirls at the start of the new term, and picking up a conker freshly hatched from its spiky shell, shiny and smooth as the flank of a racehorse, holding it for a while in the hollow of your hand and then secreting it in your pocket . . . A girl thing.

I tell my new friend how upset I often am on my arrival in Paris when I find out that a project – an anthology of short stories, literary event or panel session, where I would naturally have had a place – has been put together without me, and I'm told: 'What a pity, we didn't think of you, you're so far away.' On the verge of tears, I moan:

'New York isn't the Gobi desert! There is such a thing as the telephone . . . email!'

'It's hard to fight against these people's parochialism,' replies the soft, earnest, voice. 'But *I'll* call you

even when you're over there.'

I very quickly become a regular at the office where she reigns over a little court of female staff. This office is a special place, a cocoon. People kiss me, compliment me, offer me work. I see a future. I'm part of the Queen Bee's inner circle. She gives me the most wonderful gift anyone can give: belonging.

Because, albeit reluctantly, I'm one of those people who hop from one continent to the other, always newly arrived, born of parents and grandparents newly arrived. But what do we dream of? A house in suburbia, with pipe and felt slippers. Or of childhood in the Luxembourg Gardens. We are great sentimentalists. But the house in suburbia isn't within our grasp, slippers are out of fashion, childhood in the Luxembourg, or what we were able to grab of it, eludes us and vanishes in the mist. We are the sort who are always being asked, wherever we are: 'Oh, passing through, are you?' and people are surprised at our presence.

A few days after my arrival, as a child, in France, my native land where I had not been born, I was taken to the Luxembourg Gardens. I'd just learned to read, and was darting excitedly from one queen to the next to decipher their names: the very wise Saint Bathildis and the curvaceous Clémence Isaure were my first Paris friends.

For me, born a long way from Europe, the daugh-

ter of Jews forced into exile, childhood in the 'Luco', as we called it, had been an education, something that had to be conquered, earned. I had the impression that the Queen Bee, who was descended from minor Limousin nobility settled in Paris, hadn't had to conquer anything. She'd been born among the queens of the Luxembourg Gardens, she belonged. 'How mistaken you are,' she replied, 'my true fate, the one I escaped, would have been to serve tea in Limoges porcelain to the bigwigs of a little provincial town. I'm a survivor, a refugee. You see, we're kindred spirits.'

And then shopping together, fits of giggles as we recall our schooldays. Memories and fits of giggles interspersed with compliments. My goodness, so many compliments. Notes, pretty postcards, sweetness and light . . . Enthralled, I bathed, for the first time since my long-ago adolescence, in the delicious froth of a perfect friendship.

Not so enthralled, however, as to be unaware that flattery was a requirement in this wonderful friendship full of tenderness.

'I so love your description of those childhood years. It's both sad and magical, and so spot-on,' I said with the utmost sincerity.

'Thank you, thank you,' replied the dulcet voice. 'Your opinion matters a lot to me. I have very little self-confidence. It's so awful, the people who say to

you, "I loved your last novel, so I can take the liberty of admitting to you that I wasn't very keen on the one before that".'

'A person compliments you and then makes you pay for it immediately afterwards by coming out with a negative comment. It's a question of balance.'

Of the two of us, I was the most philosophical, or simply the most resigned. And when we were separated by the Atlantic Ocean, emails flew like arrows between Paris and New York.

'I didn't dare tell you how happy and proud your call made me feel. Later, when I was vacuuming – yes, that's my humble little housewife side – I smiled to myself to think I had a friend in New York,' wrote my Parisian friend.

And me too, washing the dishes in Manhattan, I smiled like an idiot, I laughed with the joy of friendship.

The emails continued to arrive.

'Think of your poor friend in Paris waiting in trepidation for the critics' verdict. That moment when your book comes out, that moment when you find yourself, poor, cowering creature, thrown to the wolves, is such a difficult time. So-and-so, in his programme yesterday, spoke about three guys whose books came out on the same day as mine. Does he mention my book? No, nothing, not a word.'

I immediately sympathise: 'That's awful. But I know you'll get some lovely reviews, tomorrow, the day after tomorrow. Hang in there!'

'You're right. Let's stop whingeing.'

I play the absurd role of the elderly nurse whose job is to comfort the princess. But all that goes so well with the silky hair and blue eyes spangled with gold. And besides, the whingeing, cowering creature is in a position of strength. She's the one who queens it over the hive, not me. So now is not the time to remind her that I sent her a manuscript and she promised to read it and give me some feedback, but she hasn't mentioned it.

My a novel about a delicate subject, painful for me, and she'd encouraged me to write it. In my moments of doubt and uncertainty, her honeyed, earnest voice reassured me.

'You know that there's a demon whose job is to stop you from writing. You heard his voice. Fight back!'

And me, delighted that she understands me so well:

'You've also come across that demon who does his damnedest to nip each of my words in the bud?'

'Of course. We're old acquaintances.'

We both believe in the demon who stops us from writing.

When I decide to go back to Japan, where I once spent some time with my father, she raves: 'I know

Japan is deeply rooted in you. You're going to send me despatches, I'm sure we'll do something with them.'

I'm given to understand that there's a film project in the air.

At present, a foreigner and illiterate, because I can't read Japanese, I comb the city in all directions. I rack my brains to find words to describe things that are beautiful, funny or hideous, expressions that will make those blue eyes light up with a shared complicity. Twice a week, ensconced in Las Chicas, a glass of sangria within reach, I send my 'despatches'.

'I know you'd share my horror of "ants". Today, in Yokohama, I had a moment of panic when I saw a crowd of people, all dressed in identical dark suits, coming towards me at speed, like a tidal wave. The men advancing with long strides, the women with hurried little steps. I thought I'd be swallowed up, but no, the ants are very good at skirting the minor obstacle of a terrified, lone tourist.

'A quaint little detail: the terrified, lone tourist is wearing lipstick! "In Japan, a lady must wear make-up and dress . . . like a lady," so my Japanese friends tell me.'

In the Tokyo metro, where I spend a lot of time, I imagine the woman I call Queen Bee sitting beside me. Whispering conspiratorially, we'd decipher the indecipherable faces, certain of having understood. But almost immediately we'd have to face the facts: we'd

understood nothing at all. We'd be afraid of getting lost, of missing our stop. Together, we'd be foreigners in the land of ants.

I write:

'When Japanese friends told me, before my trip, that I'd see the cherry blossom, I replied politely: "Cherry blossom, how lovely, I'm thrilled". I had no clue. I didn't realise that I'd walk for days under a shower of petals, that I'd see pink rivers and at night I'd join long, slow processions, dark rivers mirroring the pale rivers of petals, and that like everyone else I'd hold my camera high above my head to capture and possess a tiny fragment of the stunning, soft, pink mass.'

Very quickly I receive a reply.

'What a beautiful and moving account of the pale blossom! I'll never tire of the Japan described by you. Say hi to every cherry tree from me.'

Heartened, I continue to send my impressions.

'Yesterday, in the Tokyo metro which I'm beginning to know well, an elderly woman drops her bag of shopping. She panics. Several snoozing men open one eye and quickly shut it again. I bend down and help her pick everything up. She bows, thanks me and gets off the train. Her three neighbours, a man and two women almost as old as she is, stand up and make several perfectly synchronised bows to me. I don't quite understand these bows, but I had the sense I'd taken part

in a "Japanese moment". I wasn't *nobody*. You see, it's possible, even in a city like Tokyo.'

I'm alluding to an afternoon when we were walking together in the Luxembourg Gardens, all autumnal yellows and russet, talking about travelling. She told me she didn't like staying in foreign cities. Being in a city where she was nobody, she said, was neither pleasant nor comfortable. I'd never thought of that aspect of travelling: the unpleasantness of being nobody. While I found this little weakness a bit ridiculous, I was touched by the charming confession of my new friend who, in Paris, was undeniably somebody.

Then came the day when I wrote: 'This morning, again in the metro, I wondered where all the women of my age were. Horror! They're everywhere. Sexless, unattractive creatures, the *oba-chan*, the grandmothers! Greyish trousers, burgundy, deep-purple or brown jacket, and an ugly little round hat like a mushroom, in the same colours. At what age do you find you've become a mushroom-woman? I have to leave this country quickly before I too change into a mushroom!'

I barely have time to take a few sips of sangria before the answer flashes up on the screen:

'Dear Chinese Mushroom, keep sending me the fruits of your astute observations. Paris is grey and dull.'

And all of a sudden that geographically displaced mushroom takes on the sinister air of a poisonous

fungus. It has transformed me into a clairvoyant, certain of betrayal, abandonment. Everything will happen exactly as I foresaw during that strange moment of revelation when a mushroom was the bearer of the message that my beautiful dream of belonging had been no more than that: a dream.

Self-portrait with dog

In 1938, Frida Kahlo painted herself with her itzcuintli, a hairless Mexican dog. Tiny, black and attentive, the dog stands in front of her, its pointed ears pricked up. This breed has a special significance because its role is to accompany the dead on their journey to eternity. It is also called Xoloitzcuintli, after Xolotl, the god of death, often depicted by the Aztecs with a dog's head. The animal painted by Frida Kahlo is much smaller than in real life. Frida is sitting on a chair, facing the viewer, her hands folded in her lap, wearing a black dress over a full, white petticoat. She is beautiful, with a full, red mouth and the famous fuzz above her upper lip, which she rarely fails to include in her self-portraits. Although tiny, the dog appears to be guarding its mistress. Both the woman with her big black eyes, and the dog with its small, bulging orbs, gaze at the spectator with a defiant air.

This painting is very different from the many portraits and self-portraits of artists with their dogs in which the animal is sometimes portrayed as noble, but always submissive, the best friend

of his master or mistress who controls it and has it on a lead, or it nestles in their lap like a cuddly toy to be idly stroked. In Frida Kahlo's painting, while there is no direct contact between the woman and the dog, they share a mysterious, possibly tragic, bond, and are united in a sombre pride.

I'll paint myself sitting in an armchair, in front of a hearth where a fire is burning. At first it looks joyful and welcoming, because a fire in a fireplace creates a feeling of happiness and comfort. But on looking closer, you see there is something sinister and threatening about the tall, opaque flames. I am dressed in typical New England country clothes: jeans and polo-neck sweater under a checked flannel shirt. I'm depicted in profile. My tilted face is partially hidden by my curly black hair with henna highlights. I'm leaning towards a large dog, of a smooth, rich, mahogany colour, the flames reflected in his coat. His long, smooth nose rests in my lap. I have one hand on his head. The dog, which is the main subject of this painting, is not looking at the viewer but gazes up at me with elongated eyes the colour of very dark amber, the bluish whites contrasting sharply with his dark, russet coat. The dread and anxiety in his gaze suffuse the canvas.

*

I am not a dog lover. I'm happy to stroke them when they're well behaved and clean, with a glossy coat, but I've never felt the need to have one. When a dog bounds towards me, even if it's not barking, inwardly I die of fear, and I'm not even ashamed to admit it. If the smallest yappy dog gives a loud bark, I'm terrified. In the normal course of my life, I have no reason to think about the canine species in general, or about any of its members. And then, one day, there was Lucky.

When I met his owners, Ted and Elisabeth, they were no longer young. They'd married late. They had a huge dog, called Winston, who would jump up excitedly when you mentioned the name of a certain dog biscuit, a bland rusk in the shape of a little bone. He'd snatch the biscuit, crunch it and then wag his tail enthusiastically, as is fitting for a well-trained dog. It goes without saying that he never tired of running to retrieve the ball or the sticks his owners threw as far as they could, knowing that he enjoyed this game. An uncomplicated dog in other words. He was Elisabeth's dog, from before her marriage. She liked to say that it was thanks to him that she'd learned to live with a fellow creature. Winston had taught her to share, to trust. Otherwise, she'd never have married, she'd assert with a smile.

When Winston died a natural death, Elisabeth was heartbroken for a long time. Ted was also distressed,

not so much at the death of his rival, but at his wife's grief. They would both tell their friends that their relationship worked better when there was a dog between them.

A year went by. One day, Elisabeth and Ted announced they were going to get another dog. A family that had too many children and also too many dogs had offered them Lucky.

Soon, we were invited to meet Lucky. It was in the countryside, winter was coming to an end and the thin branches on the shrubs were already red with new sap, the earth was less hard, the paths often muddy. When we walked into the house, I had a shock. I had never seen such a beautiful dog in my entire life. He seemed to be waiting for us. He didn't race over, growling or barking as dogs do when strangers enter their territory. He watched us in silence as we took off our coats and then kissed Elisabeth and Ted. Not as big as Winston, but a respectable size, Lucky was a magnificent mahogany colour. His nose was long and smooth, neither too thin nor too thick. Impossible to imagine a more perfect dog's muzzle. And yet, when I was sitting down and he rested his perfect dog's muzzle on my knees, when he looked up at me with his amber eyes, I had to keep reminding myself that this was a dog. Lucky's eyes were human eyes. Not dog eyes, those soppy eyes filled with unconditional love, eyes

whose role was to remind you that even if you'd committed a heinous crime, such as murdering an old lady or hiding a razor blade in an apple you gave a child on Halloween – the most unforgiveable crime, in my opinion – not only does your dog not despise you, but he loves you no less. And lets you know it by gazing at you with his soppy dog's eyes. His man's-best-friend eyes.

Lucky didn't have man's-best-friend eyes. He had the eyes of a hunted man. Elongated, anxious eyes that were never still. He often looked to the side, almost without moving his head, always on the alert. Lucky's gaze was that of the person who doesn't know when the executioner will choose to come up behind him with rapid, muffled steps, or from where the fatal blow will come. He knows only one thing, and that is that the blow will come.

Lucky had a past, most likely unhappy, which he recounted in the only way he could. He hated cameras, even placed on the floor. He would make a huge detour to avoid going near the smallest little disposable Kodak lying in a corner of the porch. He couldn't bear the dark, except in the city, where the darkness was softened by the glow from the street lights. In the country, nothing could persuade him to go outside after sunset. When they forgot to feed him, he did not protest. He didn't rattle his bowl to let them

know he was hungry. He waited, and his expression became just a little more fretful. When they gave him the bland little bone biscuits his predecessor so loved, he ate them with an obvious but discreet pleasure, and his efforts to obtain a second one were dignified. No whining, no dancing on his hind legs, no outstretched paw scratching your arms or your clothes, none of those canine wiles that dog-owners find so amusing. He didn't beg. He did not demean himself.

During the following months, I saw Lucky regularly. Elisabeth and Ted, worried about the unusual, so un-doglike temperament of this new family member, said they were grateful for my support and kept me informed of Lucky's progress: he seemed to have enjoyed his weekend in the country house, he'd sniffed around a fox's lair for ages, he'd chased a squirrel, he'd spent the afternoon scampering around in the woods like a real dog. But on two points he'd remained uncompromising: he wouldn't allow himself to be photographed, and he refused to go with them on their evening walk, at the hour when the air was filled with the chirping of spring peeper frogs, the first audible signs of the coming season. He must have been afraid of the demons that haunt the night.

Meanwhile, I had become obsessed with Lucky's eyes. Those oval eyes that darted anxiously about, revealing their blue-tinged whites. Those eyes filled

with an anguish that had seemed strangely familiar to me from the moment I first saw him. A very ancient, deep-rooted angst. Yes, I know, people will think I'm mad. I started to look into the eyes of every dog I met. In the city, the street, in public parks, crouched in front of a member of the canine species, I'd say to the owner: 'Excuse me, would you mind if I looked into your dog's eyes?' They were swayed by the earnest, even urgent tone of my voice. They realised immediately that this was no mere whim or eccentricity, but a genuine passion.

I soon discovered that dog-owners love talking about their pets. Far from annoying them, my request charmed them and led naturally to pleasant conversations. They were delighted to give me extensive, poignant and amusing details about the character of their best friend. Kneeling before the dachshunds, I would exclaim over the gentleness, the alertness of their gaze or the softness of their nose. I would brave the contemptuous look of Afghan hounds, stare into the plaintive eyes of bassets, or terriers' round orbs. I'd stroke the curly hair of bichons frises and poodles, and look deep into their shining little eyes. My fear had vanished, giving way to obsession. I dared go close to great Danes, which their owners held on a tight lead, proud of the control they exercised over their enormous beast.

'The whites of his eyes?' they'd echo in surprise, sometimes amusement. 'Why would you want to see the whites of his eyes? Now you come to mention it, I've never actually thought about it.' Then the owner would say to their dog: 'Here boy, show us your eyes!' And together we'd bend over to look.

No white. Or very little. Dog's eyes, no more, no less. Nothing like Lucky's eyes. I paid the obligatory compliments, dog compliments. I did so with all the more pleasure and sincerity because not one of these dogs in any way reminded me of beautiful, tragic Lucky.

I had to face up to the facts. For the first time in my life I loved a dog. Well, not a dog. Lucky.

One evening, I had a call from Elisabeth. Lucky was at the vet's. I wasn't surprised. We'd spent the previous evening at Ted and Elisabeth's, playing cards. Lying on the rug, looking dejected, Lucky watched us. He hadn't eaten anything for two days.

A week later, after an operation to remove a rubber ball lodged in his intestine, Lucky was convalescing. Elisabeth was distraught. She kept giving Lucky reprimanding looks. Winston would never have swallowed a rubber ball! Winston was a normal dog who, although he sometimes chewed shoes or sticks, never mistook them for the bland, bone-shaped biscuits. Lucky was definitely not her dream dog.

I stroked Lucky's head. I wished I could have thought

of something nice, something profound to say, words that would have helped endear him to his owners. I went so far as to venture that life rarely turns out as we'd hoped. I talked of fate. Platitudes, nonsense.

Ted, a tall, rather sharp man with stern features, not averse to giving lectures on morality, calculated the number of African children that could have been fed for the amount they'd spent at the vet's.

Elisabeth was worried. When summer came and the local children would once again be leaving their toys lying around, how could they stop this strange animal, who seemed to lack any common sense, from swallowing Lego pieces, miniature cars, soldiers or dolls? What would he stop at?

And meanwhile, African children were starving to death.

Lucky looked contrite. He walked with the cautious step of one who has a great deal to be forgiven for. He gratefully lapped up the chicken broth and rice prescribed by the vet. In his eyes you could read, yes, gratitude: he liked chicken broth.

Several weeks went by. Lucky was making visible efforts to behave like a normal dog. He trotted over to Elisabeth whenever she called his name, he followed Ted almost willingly when he went for a walk. There had been one of those spring blizzards which covered the trees, already in leaf, with a thick, heavy

blanket of snow, soon snapping the branches. While his owners tried to save their trees, bowed down to the ground, Lucky licked the snow, burying his nose in it then shaking it and sending the white powder fluttering around his head, probably to show that he was like other dogs, that he liked to play.

But he wouldn't go out at night, and he refused to let himself be photographed.

He greeted me like an old friend. He waited for me to sit down and then immediately came and rested his nose in my lap. His gaze wasn't joyful, not quite, or carefree, but all the same. Temporarily reassured, he seemed to be saying: 'You see, they operated on me, treated me, saved me. A dog doesn't forget these things.'

All through the spring, Lucky's gaze stayed with me. Spring turned into summer. One very hot day, a group of us were spending the afternoon on Ted and Elisabeth's deck. The sun was high, the bees were buzzing. The ground, strewn with pine needles and warm beneath our bare feet, smelled good, smelled of summer and lazy days. Every so often, a hummingbird would come and beat its wings very close to us. Lucky ventured a few steps onto the lawn, then he came back up to the deck. He walked pathetically around the table where we were finishing a leisurely summer lunch. He sat beside me for a long time. He placed his nose on my knees. Then one paw. Then the other. His paws were

heavy. From sorrow or tiredness. He seemed to be in pain. His eyes had become fretful again. Sometimes he glanced quickly to the side, towards his master. Ted looked annoyed, he suspected Lucky of having given in to the temptation of swallowing a toy again. That animal had no sense of self-preservation.

I told Elisabeth and Ted that for some time now, I'd been certain that their dog was Jewish. I could see it in his desperate eyes.

They smiled a forced smile. For them, it was a joke in dubious taste, of course, and I knew what they were thinking. They were thinking that Jews see Jews everywhere. Even I, their friend, carting everywhere with me in my baggage Lemberg, Brody and the other ghettos, and now dumping it on their sun-drenched deck. When your ancestors were energetic, optimistic people who arrived in the New World on the *Mayflower* endowed with a robust sense of reality, a reality which, let it be said in passing, had always favoured them, you don't believe in Jewish dogs. Elisabeth and Ted didn't believe in Jewish dogs.

Elisabeth too started talking about African children. Ted spoke of sending them the amount they'd save if . . . if the shuttlecock or the toy dinosaur swallowed by Lucky didn't pass by itself and if . . . and if . . . The pine needles were fragrant, the humming-bird beat its wings. Another operation, repeated Ted

. . . unjustifiable expense . . . Unjustifiable, echoed Elisabeth.

Nose-to-nose with Lucky, his head in my hands, I read in his eyes his pain and his fear.

I didn't listen properly to what they were saying, didn't understand, didn't want to understand. I didn't believe it.

Elisabeth didn't tell me herself. I learned the news two days later at the house of some other friends. We were sipping cold drinks in a vast garden filled with summer flowers, a riot of colour and fragrances. Our chairs were placed on an emerald lawn. When Ted and Elisabeth arrived, someone said: 'So sorry about your dog.' Someone else added: 'He was a beautiful dog.'

The chorus of condolences merged with the strident chirring of the crickets. Elisabeth thanked them. 'He didn't make it.'

She gave a sad little smile. When you take a dog to the vet to have him put down because he's guilty of swallowing a plastic duck, he's obviously got no chance of making it. Dumbstruck, I gazed at the horizon, the purple hills in the late afternoon sun. A murder had been committed.

Elisabeth repeated: 'He didn't make it.' Sitting in my corner, my eyes riveted on the view, I waited for it to be over, for them to finish offering their disgusting sympathy to a pair of murderers.

Autumn came. I don't see Ted and Elisabeth any more. I heard they'd got another dog, a spirited sheep-dog who's full of the joys of life and runs around in the dead leaves. A normal dog.

Stabat mater

A few years ago, while holidaying in a village in Tuscany, I visited the church. At Easter, the Sunday-school children had been asked to draw the Crucifixion. They must have been quite young, the infant class. The drawings of Christ on the Cross were all more or less identical, with stick arms and legs, the face a round smiley with a crown of thorns. Mary, standing at the foot of the cross, had a similarly round face wreathed in long, blue veils. The striking thing about nearly all of the drawings was the Virgin's tears, drawn with great care and sometimes even coloured in: they streamed down to the ground in long, absurd strings, looking more like sausages.

Years later, I have forgotten everything about that little church, but I still often think of those long ropes of maternal tears.

I paint myself standing, attired as if for a party in a dress with an exotic print of parrots and brightly coloured foliage, gold high-heeled sandals, straw hat

with a ribbon. I look healthy, with a summer tan, but my glasses do nothing to conceal the dark rings under my puffy eyes. Beside me is a tallish young man with broad shoulders. He stands as stiff as a tailor's dummy in front of a little rectangular brown mat. His face is handsome but cold, absolutely rigid. His black eyes are glazed. I am in profile, he is full-face. We are both looking, he warily, me anxiously, at his hand, a large hand held out, open, palm facing upwards. That hand in the foreground immediately draws the viewer's gaze because it looks inert, as if fashioned out of wax. Lying in the palm are two pills, one pink and the other purple, the bright colours contrasting sharply with the pallid hand.

A little further back, hovers a tall, sturdy nurse whose white uniform catches a little light, whereas her face is in the shadows. She holds out a plastic beaker which doubtless contains water. Behind the young man is a room with a barred window framing a very blue patch of sky and the branch of a tree with very green leaves. A ray of sunshine glances off the narrow bed and puddles on the beige carpet.

*

The hand moves up and down, up and down, palm still facing upwards, the overly pale palm cupping the two

tablets. The nurse speaks. Her tone is natural, cheerful, as if she's talking to a disobedient child: 'Come on, try a little harder.' The young man is standing in the doorway of his room. His face is blank. Closed. His palm continues to move up and down. All of a sudden, I can't take it anymore. I scream:

'Will you swallow those fucking pills!'

The result is instant. The palm rises to the mouth and tosses in the pills. The nurse holds out the glass, the water is gulped down. She congratulates us: 'Well done, that's very good.' She walks off with a lively step and the day goes on.

From the heavily barred window in the toilets, there's a view that, despite everything, can only be described as magnificent: on the other side of a lazy river in this scorching month are verdant hills and fields of ripe corn. Above, is a vast blue sky. I walk towards the row of washbasins and splash my face. The paper towels are scratchy. I blot my cheeks and forehead.

That's when I become aware of the presence, at the end basin, of an extremely fat little woman, obese, as the poor in this country often are. She washes her hands slowly, carefully, soaping each finger. When she begins to speak, it is in a husky voice. She must have been a heavy smoker. She has the accent of this area, a New England accent. She says:

'The cold water will do you good. When you came

in, I could see right away that you were upset.'

I run the cold water and splash my face a second time. I want the fat little woman to carry on talking. She doesn't need to be asked twice. 'Your eyes are red, you've been crying. That's only natural. You're new here. Everyone cries at first, then they get used to it.'

She dries her hands and smiles at me. She's missing a few teeth.

'You'll get used to it too. Don't worry. In your case, it must be nerves, it's blindingly obvious. For starters, you're too thin. They'll treat you, then you'll feel a lot better, believe me.'

I thank her and I don't tell her that I've just spent several hours watching a twenty-five-year-old man standing in front of a little mat which he refuses to cross because at the moment his senses are particularly acute and he can smell danger. I don't tell her that I am the mother of that young man and that I had to listen over the telephone all night long to his howls of ter-ror coming from a faraway emergency room where he was surrounded by enemies. That it had taken tricks, acrobatics and lies to get him into an ambulance, early in the morning, strapped to a stretcher, the frontier between the state of New York and Vermont having suddenly become impassable, because a howling young man strapped to a stretcher belongs to the state where he began to howl. And my son was howling in the state

of New York. I don't tell the kind little fat woman that this morning, he'd fought with every ounce of strength when they tried to drag him to the toilets because he knows that behind the door marked 'Men's toilets' is the gas chamber.

I finish drying my hands. They're chapped from having been scrubbed too vigorously. I run a comb through my hair.

It was during the night, a beautiful summer's night, that I learned he'd gone mad. That expression isn't used any more, of course. There are much more modern terms to describe a young man who runs off one evening into a peaceful forest in the Catskills screaming in terror because the Gestapo are pursuing him. After having earlier punched one of his colleagues whom he suspected of being an SS officer.

When I step onto the mat in the doorway of his room, a flicker of horror is visible in the young man's eyes. Not a muscle of his face moves.

I've brought a newspaper. A sports paper, because he's always been a sports fan. I put the paper on the bedside table. Without changing position, he lowers his head just enough to glance at it. Out loud he reads a headline and then an entire paragraph. It is his voice.

Heartened, I take his hand. I desperately want the little victory that would consist of getting him to step onto the mat. His hand does not respond. His arm is

tense, ready to withdraw the hand at the first hint of danger. I say:

'Look, I'm treading on the mat. It's just a little mat, it's not even pretty. Come, you try. There's nothing to be afraid of.'

I tug him gently.

'Come on, let's try. I'm here.'

He frees his hand, moaning softly, and resumes his position. He stares at the mat again.

I change the subject.

'You were interested in the paper. I'll bring you others, if you like.'

He doesn't answer. I keep talking:

'It's a lovely day. This is a pretty room. You're going to get some rest.' His face expresses only suspicion.

I try to approach him. I put my hand on his shoulder. He recoils a step. The suspicion has turned to terror. I notice a faint smell, which is not his usual smell, the familiar smell of the body that I have known for as long as he has been in the world.

For my visit to the hospital, I dress up in a pretty outfit with gold sandals. Sitting for hours in the wide corridor, I knit a beige sweater that I will definitely never wear.

I reply politely to friends who say: 'I wouldn't be able to cope if something like that happened to my son.' I don't tell them that it could happen to anyone. And that

they would cope, as people do. They'd have no choice. I don't reply that they deserve to have it happen to them. Deep down, I agree that it is unlikely to happen to them. Not to them.

At night I sleep in a little house in the middle of the woods. At first, I was scared, alone among all those trees. The dark, the sounds of the forest. Supposing there were prowlers. Now I no longer feel at all scared. When I finally fall asleep, I dream of the child with shining eyes who used to laugh, run, snuggle up to me and jump up again, his lithe body full of the joys of life. I love the neighbours who come down the hill in the morning to bring me warm bread and a thermos of coffee. Yes, I love them. Even if afterwards they insist on telling me they wouldn't be able to cope.

I try to put an apple in the hand of the young man with glazed eyes. He withdraws his hand as if the fruit is burning him, or is about to explode. I can't help shouting: 'It's an apple, an apple I've brought you, a green apple, the kind you like. Eat it!'

I watch the young man reach out, fearfully, for the fruit. His hand is large, pale and stiff. It belongs to no one in particular. I can't say with certainty that it is my son's hand. The hand advances, retreats, advances, snatches the apple and raises it slowly to his mouth, moves away, starts all over again. He finally sinks his teeth into the apple, once, twice, like a robot, his gaze

lost in the void, one bite for mama, and then another.

He drops the apple which rolls on the floor. I hastily pick it up and rush to the toilets to vomit. As I dry my face in front of the stunning view, the lazy river and the trees so green, I repeat to myself the reassuring words which others, those same people who wouldn't be able to cope, use to minimise, prettify, terminologise the pain and the terror: your son has lost the plot, he's flipped his lid. It's just a little psychotic episode, nothing to get worked up about.

In the room, I find things exactly as I left them. I go back to my place beside the young man, my son, a statue with dull, glazed eyes before an impassable little brown mat.

Self-portrait as an author

In 1632, Judith Leyster, one of the first female painters to belong to the Haarlem Guild of St Luke, depicts herself at the easel, working on the portrait of a jolly violin player, straight out of one of the genre paintings for which she was famed. This self-portrait is probably her presentation piece to the Guild. We see a young woman with a laughing expression, full lips, a pleasant, slightly lopsided smile, small eyes and a very direct gaze. Her hair is scraped back under a white headdress, similar to the ones worn by nearly all the women in her paintings. The artist is turned towards the viewer, her elbow rests on the back of her chair and she is holding a paintbrush. She looks relaxed, even though the long sleeves trimmed with delicate lace and the enormous starched white ruff do not look very practical for painting. But that is not the point. The point is to show not only her talent, but also her elegant outfit – that of a young woman from a respectable family – and her good humour, her amiability. Judith Leyster's family needs money. In the Netherlands, a painter is a businessperson

like any other. This self-portrait must be an advertisement for the artist and for the portraits of musicians and lively genre paintings that had made her so popular. The point is to promote herself!

I'm going to paint myself sitting at a table with three piles of books in front of me. My name can be seen on the covers. The scene takes place at some book festival in Paris or the provinces. I am facing the viewer who can see me exactly as a person standing in front of the table would see me. They see a woman with black, frizzy hair with auburn highlights looking cheerfully up at them with shining hazel eyes behind thin, wire-framed glasses, her well-defined lips stretched in an amiable smile, slightly forced, slightly ironic – in any case, a smile that isn't entirely spontaneous. I'm wearing a figure-hugging grey sweater and a chunky, brightly coloured bead necklace. My elbows are resting on the table. I share the centre of the painting with a large bottle of mineral water standing between two piles of books.

*

The lady in the dark-brown suede jacket has grabbed a book. Suddenly attentive, sitting up in my chair, elbows on the table, I push aside the bottle of Évian. I smile at the lady dressed in suede. I smile at her but

not too insistently, a relaxed, friendly smile. I'm here so we can chat, but only if you want to, of course, I'm a well-behaved author, and anyway, it's all just for fun – yours, mine – an enjoyable conversation perhaps, who knows, let's try!

The lady weighs up the book. Puts it back on the table. Picks it up again. Flicks through it, reads the back cover and looks at me to check whether what she's just read matches – I'm not sure how – but matches what she reads in my face. She asks:

'Are they short stories?'

Me, still smiling, amiable – I'm an amiable author – I nod my head putting on a slightly mischievous air:

'Yes, short stories.'

The lady in suede turns to a paunchy man in black leather standing idly behind her, who makes no effort to disguise his boredom.

'You don't really like short stories, do you, darling?'

'Not particularly.'

'That's what I thought. Shall we go?'

Without a glance at me, the lady turns on her heel. The suede-leather couple walks off. The book has fallen haphazardly onto the table.

I grasp the bottle of Évian and fill the glass. Luckily there's the mineral water which, I quickly realise, is there not so much to quench the author's thirst but to act as a prop enabling her to maintain her dignity.

But already I look up, filled with hope, because she's coming over to my table, the woman who's going to let herself be tempted, enthralled, by my book. Tall, frizzy-haired like me, in her fifties, discreetly made-up, she comes over and I smile at her, glass of water in hand, as if I were drinking to her health, and I'm still smiling because I didn't detect straight away the contempt, the scorn, in her eyes. Those are rotten fruits, mouldy tomatoes, overripe pears you're selling there, my girl, you weren't seriously expecting me to stop and show an interest, were you, say her eyes as they sweep my stall. I gulp back my smile.

A man rushes towards me brandishing a camera. I look up, self-conscious, sparkling, charmed by this promising zeal. He doesn't look at me. He's out of breath.

'You don't mind if I stand here for a moment, just while I take a photo?' He's already perched on my table, on my books, he has no interest in me whatsoever, he's busy photographing a man whose tan is heightened by a pink shirt unbuttoned down to his navel, and whose books, spread over a huge table, are about how to stay cheerful when spending your holidays with various family members. One book for your mother-in-law, one for your father-in-law, one for your daughter-in-law, one for the grandchildren . . .

'There, all done! Thank you! What a piece of luck! I couldn't miss the opportunity!'

Rapidly and clumsily putting my books back, having destroyed the tasteful display, he gratifies me with a broad, smug grin to which I am careful not to respond churlishly – it's a matter of pride. So I flash him an understanding, almost knowing smile that says it's completely normal to sit on my modest production to photograph the author whose works are so much more important.

I am consoled by the arrival of two intellectual-looking forty-somethings, who both place a hand on my books and caress them affectionately, almost lovingly. The woman leans over to me.

'I can't wait to read this book, it looks very interesting and I read the review in *Télérama*. Brilliant! You must be thrilled!'

I hold out a copy.

'Would you like me to sign it?'

She waves her hand dismissively as if to reassure me.

'No, no, don't worry, I have a colleague who can get it for me through his girlfriend who knows someone in publicity.'

Once again, the face-saving Évian. The bottle will soon be empty.

But the publisher is never far away. He keeps watch over his author, ready to step in. He's more at ease, because he's a commercial animal, not an author. He's here to sell, shamelessly. So am I, I'm here to sell, but

it has a different connotation in my mind, the mind of a sensitive, gracious author. I'd like people, lots of people, to think my book was worth their opening their bag or wallet and taking out some money or their bank card. I'd like them to take my book home like a trophy, a treasure, and to read it, to read me. That on reading it, they pause to re-read a sentence, because it's a sentence that resonates with them, affects them, amuses them, surprises them or, quite simply, they find pleasing.

And so the publisher flies to the aid of his beggar-author. We're going to address the customer, reel them in:

'Hello, sir, can I help you?'

The gentleman with tortoiseshell spectacles, not very young, greenish tweed jacket which isn't very young either, has opened a book and slid a pudgy finger, a sausage finger, between two pages. He doesn't look at the spread pages, he looks at the author and the publisher, warily, then replies:

'No, not really. I was just looking.'

I understand the gentleman in the greenish jacket and the tortoiseshell spectacles. At the market, the stallholders who yell the merits of their tomatoes and their melons at the top of their voices often make me laugh, but don't necessarily make me want to eat tomatoes or melon. However the gentleman still hasn't

taken his pudgy finger out of the book, whose cover he is now scrutinising. He asks:

'Is it literature?'

I laugh. I'm an author with a sense of humour.

'Yes, sir, it's literature. Guaranteed.'

'Because if it's to read the same sort of thing you see in the papers every morning, no thank you.'

Again, I laugh.

'I understand. But no, what I write is nothing like what you read in the papers. It's literature.'

Since the sausage finger is still between the pages of my book, I grow bolder, putting on a cheerful voice.

'Go on, take the plunge! Why not?'

And now the publisher decides to take things back in hand.

'It's a very fine book, sir. Read the reviews on the back.'

Aaagh, that was the wrong thing to say. The sausage finger is quickly retracted, the violated book bounces as it crashes back onto the table, permanently half-opened, deflowered.

'The press. So you admit that everything always comes back to the papers.'

Frowning face, irritated tone. The greenish jacket walks off. But already a short, thin man in a hurry has taken his place and is holding out a copy of one of my books, crumpled, stained, torn, the cover held in place

with yards of Sellotape.

'Ah, madame, I'm so happy to have found you! Look at this book. I can tell you it's done the rounds! My entire family's read it, my sister and her husband, and also my niece who's studying for her baccalaureate. I've only just got it back. It was in such a state, I can tell you, but I've stuck it back together again. I'll bet you're delighted to hear that, aren't you? May I have a little autograph?'

That's when the gracious author starts to feel uneasy. I'd like to reply with sincerity that yes, I'm absolutely delighted, and happily sign the book without bitterness, forgetting that I am dying to ask this man-in-a-hurry brandishing the grubby Sellotape-covered book in my face whether his vast family might not by any chance be able to afford a second copy of this book they so love. Or one of my other books.

I reply: 'Yes, I'm absolutely delighted.'

I give him a little autograph. The piles of books have not dwindled. The bottle of Évian, meanwhile, is empty.

Self-portrait on the beach

In 1946, Frida Kahlo painted a double self-portrait entitled Tree of Hope. *In one image she is lying on her side enveloped in a sheet, on a wide gurney, and in the other, she is facing the viewer, sitting upright on a wooden seat with its back against the gurney. She is wearing a magnificent red dress with a white flounce. Of the prone Frida, we see only her loose black hair and her lower back displaying two long, bleeding wounds, incisions from the surgery she has recently undergone. The seated Frida wears a festive hairstyle, a bow that resembles a big red flower on her head. Her face is serene, but a tear runs down her cheek. She is holding an orthopaedic corset and a yellow flag with the words 'Árbol de la esperanza, mantente firme' (Tree of hope, remain strong!). The surrounding landscape is strange and desert-like, with two huge orbs, the moon and the sun, suspended in a stormy sky.*

I am going to paint a dual self-portrait too, but with myself the centre of an idyllic scene: a perfect beach,

white sand, a vast, very blue sky and a blue sea. I am lying on my back. The legs of my sunbed are in the water. My upper body is wrapped in a white blanket and I'm wearing a leopard-skin bikini. The bikini only partially conceals the long, still-fresh line of stitches scarring my stomach. My eyes are closed, no glasses, and I'm smiling like a person sunbathing, lulled by the gentle sound of the lapping wavelets. Here I am again, sitting bolt upright on the edge of the bed, legs dangling, facing the viewer. I'm wearing a long, black, asymmetrical dress, crumpled in unexpected places, with a flounce on one side only and oddly positioned pockets. My black hair with auburn highlights is frizzy and very thick. I don't push realism so far as to adorn my upper lip with a faint moustache as Frida Kahlo does. I'm wearing round glasses, with a purple metal frame, and my expression is stern.

*

The beach is the perfect place for people to show off their tattoos. A bee adorns the breast of one young woman, a snake writhes gracefully on the shoulder of another, and there are hearts and leaf designs. As for me, I have three very clear, lovely blue-black little dots – one on each hip and the third on my lower belly, just at the base of the long scar that ends several centime-

tres above my navel. The choice of position is not mine and is a little risqué. I wish I had three ladybirds or even three midges, but I have to content myself with dots. I feel a slight pang. Some people have such pretty tattoos.

I come and sunbathe every day on this beach, except at weekends. The sessions last thirty minutes, no more, no less. I must keep perfectly still. From time to time, the sunbed makes strange noises. It folds and unfolds its great robot arms in a mysterious choreography which I do not try to fathom. I listen to the waves, I feel the spray coming off them and it cools me down. When I was little, my mother wouldn't allow me to stay out in the sun for too long. She said I could catch tuberculosis. Or worse.

On my first visit to the tanning room, I was greeted by an immensely tall and very strong black nurse. He smiled at me.

'You, madam, are a teacher and an artist,' he stated, before I could even open my mouth.

I laughed.

'How can you tell?'

'When you came in, the way you walked towards me, the way you looked at me, I said to myself: "Oh no, she's going to call me up to the blackboard and I haven't done my homework". And your dress is the dress of an artist.'

Each day I wear a different bikini to charm the tall black Hercules who lifts me as if I were a feather and places me gently on the sun lounger for my tanning session. I want to prove to him that his diagnosis was absolutely accurate and that I am a true artist. I have bought scores of panties of every hue, with polka-dots, stripes, check, floral, heart or butterfly patterns. To make up for the tattoos which are not particularly alluring.

I've already had my three little dots for three weeks. While the tattooist, an attractive man with an Italian name, was tattooing me, interested only in the lower part of my body, Doctor R., standing by my head, bent over and smiled at me.

I felt it was the right moment to start a proper conversation with the good doctor. I had already gathered that he was passionate about the Talmud. I asked him if it was kosher, all these tattoos that were practised under his authority. I cited Leviticus, which is categorical: 'You shall not make any cuttings in your flesh for the dead nor print any marks upon you.' Doctor R. smiled delightedly. He may even have rubbed his hands together, but I can't be sure.

'Fascinating question which all the rabbis have examined! You know, of course, that in *Tractate Makkot*, the Mishnah states that etching markings on the skin is a transgression punishable by flogging, and, for

the sake of clarity, it specifies that there must be both writing with ink or dye and incision to enable the dye to penetrate. The person who writes without making an incision or who makes an incision without allowing dye to penetrate the skin, is not culpable.'

The doctor's eyes shone behind his glasses. He was off. As he spoke, he adjusted his black skullcap which had slipped to the side of his head.

'I'm going to cite your fellow-countryman, the great Rashi of Troyes, who is without any shadow of a doubt your ancestor! He commentates the Mishnah and gives a wonderful definition of what we call tattooing. "First he writes on his flesh with paint or red dye and afterwards he etches in the flesh with a needle or a knife, and the colour enters between the skin and the flesh and is visible in it for all his days." And Rashi uses a *laaz* – an old French word – he uses the word *pointurer*, or making many small prickings of the skin.'

The Italian tattooist was still bent over my stomach. By dint of *'pointuring'*, he was now on his third dot. It was not pleasant. I must have winced. Doctor R. glanced at my hip and reassured me.

'It's almost done, but the discussion isn't over, by any means. Rabbis love arguing, as you know. In the same passage of the Mishnah, you can also read: "Rabbi Shimon ben Yehuda says in the name of Rabbi Shimon that one is liable only if he inscribes a name of an idol",

113

however other marks are also prohibited. Maimonides says that all etching-in is prohibited and that the prohibition stems from the fact that it was the custom of idol worshippers to inscribe the name of a deity on their bodies to proclaim that they belonged to that deity as slaves and dedicated themselves to serving him or her.'

The tattooist blew on his work, cooling my abdomen. I gave the doctor a charming smile.

'What about me then?'

I knew the answer:

'When it's a matter of life and death, anything is permitted.'

That was already three weeks ago. Doctor R. is interested in me. I see him every day, and every day we discuss the Talmud. He strides across the waiting room to come and bend down to talk to me. Sometimes, he takes my hand and asks how I'm feeling. If I didn't already have a husband, I'm sure he'd want to marry me. He's a widower and he likes my tattoos very much.

As for Hercules, lifting people who have to tan themselves is his secondary job. He pilots private planes. He promises to fly me to Paris if I want. If the opportunity arises. Between tanning sessions.

On Sunday, on the real beach, I lie at the water's edge, on the wet sand covered in foam. The tide is coming in. The wavelets cool my back and legs. A slightly bigger

wave washes across my body, rolls it gently over the sand, then ebbs. I close my eyes. My head is filled with the sounds of the sea. I preciously store enough splishing and splashing to last me the entire week.

Self-portrait as a maker of idols

I like the self-portrait of Giovanna Fratellini, painted in 1720. The brush in her right hand, the palette on her left thumb, she is putting the finishing touches to a small portrait of her son Lorenzo: in an oval frame we see the pretty face of a young man with a rosy complexion and large eyes beneath heavy eyebrows. By 1720, the artist – who was lady-in-waiting to the Grand Duchess Vittoria della Rovere – had already established a reputation, and Giovanna Fratellini's miniature portraits were highly prized at the court of the Medicis.

Here, she depicts herself as a radiant fifty-year-old: blue ribbons in her hair, pretty cheeks, an animated gaze, a little tired maybe, but happy; thin lips and a gentle, proud smile. She sits at her easel, her face three-quarters turned towards the viewer who can admire her lovely strong neck and slightly plump shoulders emerging from a diaphanous silk stole, softly draped around her. She seems to be looking round just long enough to greet a visitor who must remain unobtrusive and understand that she is wholly absorbed in painting her son.

A kitchen, at night. Bathed in a uniform light coming from the ceiling, which is out of sight. A narrow kitchen table is pushed up against a salmon-pink wall, which lends warmth to the entire scene that would otherwise be rather dreary. A woman in a teal dressing-gown is seated at the table covered with a blue-and-white gingham oilcloth. Behind her are wooden shelves stocked with groceries – tins of tea, cocoa and lentils, and an ugly, dark-frame sash window overlooking a dismal courtyard and two other similarly ugly sash windows, illuminated with a yellow glow.

The atmosphere, both intimate and disturbing, is reminiscent of certain paintings by Hopper. The woman is lost in a dream from which the viewer is excluded. Her sleeves rolled up, her hands plunged in a large salad bowl, she is kneading a greyish mass with both hands, but has her head turned towards the viewer to whom she addresses a faint, vacant smile. Her hair is pushed back behind her ears. The eyes of this woman-who-is-me are puffy, the eyes of an insomniac. But her gaze is surprisingly calm and joyful.

*

Once rid of the spectator, I go back to work, earnest and concentrated in the relative quiet of the New York night. The salad bowl is filled with newsprint ripped

into tiny shreds. I prefer the weekly edition of *Le Monde* to *The New York Times*. *Le Monde* disintegrates better and gives a smoother and, most importantly, cleaner pulp; there's too much ink in *The New York Times*. Before going to bed, I put the paper to soak in boiling water and flour paste. I prepare in the evening the work for the coming night.

I make idols. Like Terah, Abraham's father. Terah probably had some talent for sculpture and modelling. I have none whatsoever. Terah made his statuettes to sell. I don't. I know and like the story of Terah . . . And so, my possibly shocked reader will understand that my production of idols is not to be taken too seriously and that my attitude towards my little papier-mâché figures is not without irony.

According to Jewish tradition, Terah manufactured idols. One day, he entrusted the young Abraham with the task of selling them. A man came and said:

'I am strong and I want an idol that is strong like me.'

Abraham sold him one. As he was leaving, Abraham asked him:

'How old are you?'

The man replied:

'Fifty.'

Abraham exclaimed:

'Woe to this man! Here he is at fifty, wanting to bow down to an idol that has been made today!'

The customer returned the idol and took back his money.

Another time, an elderly woman holding a measure of flour came to find Abraham. She said:

'Go and offer this flour to the idols.'

Then he picked up a stick, smashed all the idols and put the stick in the hand of the biggest one. On Terah's return, he cried:

'Who has done this?'

'How could I keep it from you?' replied Abraham. 'A woman holding a plate of flour came and said: "Take this and offer it to them". And that is what I did. But an idol shouted: "I'll be the first to eat it." Another shouted: "No, I will!" Then the biggest one grabbed a stick and smashed them all.'

'Why do you mock me?' asked Terah. 'They can't do anything!'

'Can't they?' replied Abraham. 'May your ears hear what your mouth says!'

If asked, I would of course say, like Terah, that they can't do anything. And yet, I had the impression one day or, more accurately, one night, that the existing gods were no longer sufficient. My circumstances called for personal gods to serve me and me alone. I recalled the story of a Christian missionary in Africa – this took place during the colonial period – who, on meeting a 'native' carrying his little god under his arm,

asked him whether this god was strong and powerful.

'Very strong and very powerful,' replied the man.

'And does he protect you?'

'Of course he protects me.'

'But come on, you carved him yourself out of a piece of wood.'

'Yes, and because I made him myself, I know he's powerful and protects me.'

I squeeze and knead the grey mass and the cloudy water runs between my chapped fingers. First of all I shape a head: it is round or long, flat or pointed, depending on my mood or on how it turns out. The head will be embellished or not with a nose, a snout or horns, or it will have two faces, like the Roman god Janus. The body is always more or less the same, a sort of inverted cone. I'm not interested in the body. My idols have no arms or legs, it is their heads that differentiate them. Their faces. Their eyes. I scoop out sockets, I push in imitation precious stones – rubies, topazes, emeralds. Others don't have sockets, they will have painted eyes. Bulging red eyes, flat yellow eyes. Or huge white eyes with gold pupils. Some look vaguely human, others are like strange fowl. Some have the air of aliens made by a very naïve hand, because, as I said before, I have no talent for sculpting. And I am no good at drawing or painting either.

From my salad bowl filled with a murky sludge, I

fish out tiny shreds of soft, gooey paper which I plaster on various places so that my idols have a more symmetrical head or smoother cheeks. The surgeon too must have gone fishing to restore a shape to my son's face. He had to fish out minuscule fragments of bone, piece back together the eyebrow arch, the socket, the cheekbone – whose anatomical name is the zygomatic bone, as I recently learned – all broken like eggshells, shattered into a thousand pieces and embedded in the sinuses. The sinuses, I also discovered, are hollows where bone shards can get lost, but can also be retrieved.

'Luckily all those little fragments couldn't go anywhere,' jested the exhausted surgeon.

He was laughing with the joy of having given back a face to my son. Instead of painting myself at night, I could just as well have painted myself by day. I could have painted another *Stabat mater*, but I didn't. I'd have painted us, my son and myself, side by side, facing the viewer, leaning against the railing on the Hudson River promenade. Far behind us, beneath a vast blue sky, is the opposite bank of the river, New Jersey. Not especially exotic, a dark, wooded landscape with apartment buildings of a lighter colour standing out in contrast. I'd be wearing sunglasses and a black T-shirt.

Of my son, the viewer would see only his broad shoulders in a beige jacket and a bright blue baseball

cap casting its shadow over a face that is invisible any-how, concealed behind giant shades. Invisible too, of course, are his purplish-blue flesh and his eye with the top and bottom lids sewn together.

He is saying: 'Some people are telling me to forgive. They say I should forgive the person who tried to kill me.'

If I'd chosen to paint that self-portrait, I'd have had to paint myself giving a comforting smile, a mother's smile. Difficult but necessary. A mother who'd said to her son earlier: 'You're not a pretty sight but you're not ill. Get dressed, we're going for a walk in the park.' A mother who right now is saying: 'You don't have to forgive.'

'I want the guy who did this dead.'

'Of course you do.'

I'd paint myself as a mother who wants to make things better, smooth them over. If not to make him smile, that would be asking too much, at least to restore a balance. A mother who says: 'Let me just point out that we're walking in a very beautiful park by the river, while he's behind bars for a good many years.'

I'd paint myself beside my son, with only the lower part of his face visible, the chin. My son saying: 'I want him dead.'

He wants the death of the person who took great pains to wrap a brick in a terry-towel – because it's not

done to walk into a hospital armed with a brick – then waited for the moment when my son, against whom he bore a grudge, apparently, was alone in the unit to attack him and crush his face and head. And then he carried on striking an unconscious man until an electrician who, by pure chance, happened to be at the other end of the corridor, raced over and stopped him.

I say: 'Think instead of the man who saved your life.'

I add: 'If he wants a saxophone, I'll buy him a saxophone.'

Why a saxophone? I don't know. That's what immediately came into my head in my gratitude towards an electrician whom I'll probably never meet and who had saved my son's life. Several times a day, I say to myself: 'I'll buy him a saxophone.'

I could have painted a very modern picture, one of those realist portraits determined to show all, to depict life as it is, like those self-portraits of women who have just had surgery and who delight in, or feel compelled to paint or photograph themselves in full frontal view, more or less naked, mutilated, with their stitches.

In any case, this is not about me, but about my son. So I should have painted myself as a heroic mother, holding out the photos of my disfigured son, his drooping right eye with almost no socket, and the clumsy emergency stitches that made him look like Frankenstein. Or, a more realist self-portrait, namely with me

looking away from the photos taken on his arrival at the hospital. Before the stitches. Because I have always refused to look at those photos.

Could I have painted myself when I was screaming 'Who did this to you?' When I rushed over to my unrecognisable son to hug him, while being afraid to touch him for fear of hurting him?

I will carefully paint the round or pointed heads, the flat or reptilian faces. Some will be very black, others, terribly white. Or silver. Or parrot green. A very sensitive gentleman I met at the house of friends asked me with concern whether my son's face was still flesh-coloured. Now that he has all this metal in the place of bones. What exactly is flesh colour?

As for me, I only use bright colours: canary yellow, vermilion. And lots of gold paint.

Self-portraits in fugitive mirrors

Vivian Maier left thousands of photos, which were discovered after her death in 2009. Among them were hundreds of self-portraits. Erect posture, short hair, earnest-looking, slightly mysterious, Rolleiflex slung around her neck, forefinger on the shutter release, she photographs herself reflected in shop windows, looking glasses in hotel rooms or restaurants, rear-view mirrors and even hubcaps.

Of all these self-portraits, the one I love, the one that deeply moves me, is the photo of her in New York, on 3 February 1955, in a long, rectangular mirror being transported by a removal man. He has just extracted it from a pile of bedcovers and is holding it up, at an angle. The mirror, which occupies the centre of the photo, reflects the woman armed with her Rolleiflex. She is wearing a dark coat and a little hat. She is smiling, which is quite rare in her photos.

She must have 'cheated' a little, and the photo is probably less spontaneous than it appears; the photographer must have asked

the man to stand still for a moment. No matter. She has entered into the life of this man, whom we see from behind, and she's become part of his activity as a removal man or second-hand dealer, since he is carrying her, carrying her off to somewhere in one of those drab buildings surrounding them. But no, it is only an illusion! By the time the man has walked just a few steps towards his destination, nothing will remain of the young woman in his mirror. Admittedly, the whole point of the snapshot is to capture a moment. But for me, this portrait in a mirror being taken away makes this imminent absence all the more palpable, all the more poignant.

I would have photographed myself standing in front of a large mirror being carried by two men wearing caps, seen in profile. It would be a black-and-white photo, naturally. My nose streaming from a cold, my eyes bright with fever, I'd be bundled up in sweaters and shawls and wearing a long skirt and boots, my hair dishevelled. The hands, the fingers, of the two removal men would stand out against the surface of the mirror. Behind me would be a bare sitting room, shelves emptied of their books, a wall with a faded geometric art deco pattern, and a large, paler rectangle where a picture had hung. Behind the mirror, double doors would just be visible, wide open onto another bare room.

*

It was a dismal February afternoon in 1999. The huge, ornate mirror had been installed by my grandmother, seventy years earlier, even before her furniture had been brought up to the apartment in Rue Auguste-Comte. In its baroque-style brass frame with a foliage design, as was fashionable at the time, it filled the entire space between the two windows in the sitting room. First in, it was the mirror that was the last out, transported by the employees of Monsieur Tambourini, antique dealer. It left after the books, after the furniture, after everything else. Standing alone in the sitting room, I twirled a little so that the mirror would preserve my image for as long as possible. It wasn't rational, of course, but I didn't want that mirror to lose sight of me, that mirror in which, at one time or another, all the members of my family had gazed at their reflection, including two charming, laughing young Weils, brother and sister, with thick, very curly, black hair, the eyes of mischievous twins behind round, almost identical glasses: Simone, her slim form not yet emaciated or exhausted, and André, dandyish in fine suits and buttoned-up waistcoats. That mirror in which the German officers who'd occupied the apartment during the war had probably admired themselves. They had stripped the apartment of everything except the mirror – too cumbersome. I appeared in it at the age of six, on my grandfather's knee, at ten, playing cards with

my sister and my grandparents, and then as a young woman with my black hair smoothed and tied back greeting visitors as my grandmother lay dying in the bedroom, and later with my mother and my infant son, with my son again, now a teenager, and lastly with my father, elderly, frail and alone. But when the removal men had to turn to get through the door, and I could no longer see my reflection in the now lifeless surface of the huge, flat thing they were carrying, I knew that the place where my history and already my prehistory had been played out, the place that had been my home, no longer existed.

Each time I land in Tel Aviv . . . Yes, Tel Aviv. What connection is there with Rue Auguste-Comte? None, and yet, when I first saw the photo of Vivian Maier in the mirror being transported, I immediately and simultaneously thought of Rue Auguste-Comte and Israel. So, as I was saying . . .

Each time I land in Tel Aviv, I feel the same joy, an irresistible, almost animal joy, that nothing can dent. I am jostled in Arrivals. I exit the terminal: if it's summer, the heat descends on me like a humid cloak around my shoulders or, if it's winter, a cold, unpleasant rain. The taxi driver is generally brusque and disagreeable, he smokes and the car reeks of cigarette smoke, which I detest, being a militant non-smoker; the radio blares

and deafens me, we're stuck in traffic jams, everyone is hooting . . . It's no use. I lean against the shabby, uncomfortable seat back and, in the rear-view mirror, I glimpse a person – me – whose happy face is a pleasure to look at. If, like Vivian Maier, I had a Rolleiflex slung around my neck, naturally I would photograph myself in the rear-view mirror. It would be one of my many 'selfies in the Promised Land'. But it doesn't occur to me. I sigh with happiness. I have arrived in Israel.

That day, the taxi driver was an Arab in his fifties, very friendly and rather cheerful. *'Bruchim ha-ba'im*! Welcome!'* he exclaims as we get into his car. We make small talk. The weather here, the weather in Paris. He's from Hebron. He tells us proudly that, during the 1929 massacre, his grandfather hid several Jewish families in his basement and thus saved them from certain death. He even has a 'certificate' from the rabbi. He shows us a duly stamped document which appears to be authentic. When we arrive at our destination, charmed by our encounter and the interesting conversation, he says to us with the utmost amiability: 'But you need to know that Israel doesn't exist. If the Jews want to stay, they'll be welcome, especially because they're really good at everything to do with money. But Israel, no.'

In Jerusalem, I cover miles and miles on foot. I walk there more than anywhere else, probably because I'm afraid of suicide attacks and I tend to avoid public

transport. One morning, I was walking down HaNe-vi'im street, which means 'the street of the Proph-ets'. I must have been striding confidently because, after watching me for a moment, an old woman came towards me and asked for directions. Someone was asking directions of me, in a street in Jerusalem! I was thrilled. She wasn't really an old woman, but she wasn't young. She had a dainty face and was wearing a little brown hat. Her accent when she spoke Hebrew was like mine. I asked her in French where she came from. From Toulouse. She had made *aliyah* a year ear-lier, settling in Israel on her own.

'My family knows where to find me,' she told me with a calm, happy little smile. 'I've been explaining myself for seventy years, and enough's enough. Here, we no longer need to explain ourselves, this is our home.'

Listening to her, I thought that this was my home too. Is that so surprising? Perhaps not. In some old neighbourhoods of Tel Aviv, I meet elderly people who remind me of my grandparents. Admittedly, I'm a tourist but History could very well have caused me to be born and raised here, to live here. I feel that everything concerns me and that all my photos are selfies.

In David Street, in the Old City of Jerusalem, I photographed myself in the mirror of a shop selling necklaces and beads where I was the shopkeeper that

day. There were necklaces and beads of all colours, opulent, princely lapis lazuli, soft, blue turquoise, yellow and orange Bedouin amber, of no value but tender and warm, and pretty blue frosted-glass beads that looked very ancient, genuine Roman glass, guaranteed – we all need to dream a little. A tall, nondescript Dutchman with beady blue eyes wanted earrings. I had some to sell him. Thirty shekels. Too dear. Thirty shekels, come on, that's nothing. Maybe you expect me to give them to you for nothing, and then what? Inwardly I curse all those tourists who have been told that in an Arab souk you have to bargain for everything, bargain it down so low that if you don't get what you want for nothing or nearly nothing, you've been conned.

Indide it is dark and cool in that the sun doesn't enter, but even so it's suffocating. Necklaces hang everywhere, ornate, heavy Bedouin or Yemeni wedding jewellery . . . I am sitting on a banquette covered with wool carpets of beautiful colours – the shop is full of rugs and carpets. It feels as if I'm in a tent in the middle of the desert. A young man from the neighbourhood brings me a scalding mint tea. Opposite, bathed in sunlight, the iron door painted in the blue-green that brightens the narrow streets of the Old City is tightly shut. In front of the door is the white plastic chair where the owner of the shop goes to sit from time to time to smoke and get some air. An empty orange

plastic supermarket bag dangles from the door handle. People walk past. Groups speaking in many languages. They're on their way to the Wailing Wall, accompanied by their guides. They must hurry, they've still got to see the Church of the Holy Sepulchre where they can take a photo of themselves rolling on the tombstone. That selfie will match the one they'll take tomorrow in Bethlehem when they roll on the stone where, supposedly, baby Jesus's crib was placed. These groups don't stop, don't buy anything.

I tried to sell the Dutchman the earrings, cursing him under my breath, until he went off to bargain elsewhere. I should have given them to him for nothing. That's what the Arab shopkeepers do. They make a gift, but they know what they're doing and how to play the game. I don't.

Meanwhile, accompanied by the shop owner, my husband Eric was playing a game that was way more dangerous. For years he'd longed to enter the Dome of the Rock, which is the third most important and the most beautiful of the Muslim Holy Places. The site, some say, of the holy of holies in the Temple of Solomon. Nothing of the kind, according to others. The fact remains that for years and years, Eric, who never gives up, has talked of this wish to our bead-seller. And so today, he has taken Eric there. He told him to leave his passport behind, a detail that worried me. But my job

was to mind the shop, not to organise the expedition for Eric to fulfil his dream. After an hour, they came back defeated: the shopkeeper had tried to pass Eric off as an American with Turkish roots who wished to reconnect with his Muslim heritage. The Palestinian soldiers asked him to recite the first surah of the Qu'ran. They unceremoniously refused to let him through. They'd immediately scented the fake Turk, and there was no place in the Dome for a fake Turk, even if he was motivated by a genuine desire.

And I, fake shopkeeper, had managed to sell a large, orange, genuine amber Bedouin bead to an English woman, for five shekels.

On top of the Mount of Temptation, three Palestinian women danced around me, three women with beautiful smiles, with whom I'd exchanged a few words while we were visiting the monastery. I had just watched my husband disappear from view as he was borne back down to the valley in the cable car. I'd been drinking a pomegranate juice and missed it. The three women danced and sang, clapping their hands.

'What are you singing?' I asked.

'A wedding song,' they replied so joyfully that it made me joyful too. 'We're singing you a wedding song because we're going to find you another husband. And then you'll come to live with us.'

They were primary-school teachers. Later, after drinking quite a few more pomegranate juices while arranging my wedding in Ramallah and my job as a teacher in the school for disabled children where they worked, we went back down together. I sang them French songs and we gripped one another's hands because we were very frightened as the cable car swayed above Jericho.

But the next day in Jerusalem, while I was having a rest on a bench in Sultan Suleiman Street, a group of Arab women walked past. There were a lot of them, they were probably going to visit the Rockefeller Museum. They filed past me quite slowly. I looked up and saw their faces. Each one looked at me in turn, and their eyes felt like powerful erasers that obliterated me from the bench where I was sitting. Finally, when the last women had walked past me, their gazes still directed at me reflected only the bench, and I do believe I had disappeared.

I entered the Old City through the Damascus Gate, and I stopped, as I often do, at the Austrian hospice to have a Viennese coffee and apple strudel, both topped with mountains of whipped cream, served by an amiable nun. Some German tourists sat at my table, not without asking me very politely for permission. They were retired teachers. I recommended the strudel. We exchanged a few words about the charm of the hospice,

a vestige of the Jerusalem of bygone days and an oasis of tranquillity in a bustling neighbourhood. Having drunk their coffee, they apologised to me for the harm they had done to me and to my people. They seemed very pleased. They had found in me a delightful representative of the Jewish people to whom they could apologise. Before setting off again, they took photos of themselves with me. I was happy to have been part of their visit.

I didn't snap myself at the checkpoint where, as he flicked through our passports, the young soldier asked us to give a lift to an elderly Arab woman who was waiting in the background. She was going somewhere near Bethlehem.

'She's a very nice lady and I want to help her,' he explained, 'but I'm not allowed to let her go through on foot and without ID.'

He opened the door of the car for her. She got in and thanked us. The soldier told us where to take her. During the journey she kept silent, a calm silence which she broke only to tell us where she wanted to be dropped off.

In Mea Shearim Street, in the ultra-orthodox neighbourhood, I photographed myself in the mirror of a shop where I was trying on a long, black skirt. 'I need a skirt,' I'd said amiably to the plump, middle-aged sales assistant with a heavy turban and a sour expression.

I added: 'It's for Shabbat.' Which was true. The sour expression dissipated, my fitting session took on another dimension as over and above the profit she'd make, selling me a Shabbat outfit became a *mitzvah* – a good deed. Now all smiles, she had me try on sweaters to go with the skirt and also a hat. The mirror too must have been happy: I looked the spitting image of the women who probably stood in front of it every day. Ready for Shabbat in Mea Shearim. I bought the skirt. The sweaters were really too ugly.

Among the hundreds of photos I've taken in Israel over the years, there's a photo I missed, a photo that doesn't exist. I was walking along the ramparts of the Old City, in Jerusalem, heading towards the Damascus Gate. From a distance, I saw an adolescent Arab girl who had stopped, her slim, graceful form shrouded in a long, very severe burgundy cloak and a headscarf of the same colour, leaving only her face uncovered. She was standing perfectly still, gazing at something in the grass at the foot of the wall. She seemed fascinated. She must have been about thirteen or fourteen. Barely two metres away from her, a young orthodox Jewish boy, probably around the same age, black hat pushed towards the back of his head, white shirt, black suit, was sitting on his bicycle, one foot on the ground. Just as immobile and spellbound as the girl, his eyes were riveted on the same patch of grass.

I'd have had to approach discreetly while taking out my camera, turning around, as I often do in these situations, so that the two youngsters wouldn't suspect anything. I'd have looked as if I were snapping the beautiful view of the ramparts beyond, or a selfie. Everyone takes selfies, it's a way of going unnoticed. I wouldn't have wanted to include myself in the photo: I was in it anyway, for me that was obvious, I was linked to those two children of Jerusalem.

Instead, I wasted time wondering what they were looking at. When I was ready to take my photo, it was too late. The boy had pedalled off. He rode away, hat precariously balanced on his head, sidelocks flying in the wind. The girl had resumed walking, and we exchanged a glance. Her face was inscrutable. I leaned over towards the patch of grass that had so intrigued them: a cat was finishing off a mouse. Would I have managed to include the cat and mouse in my photo? Probably not. This question preoccupied me for a good while. In the photo as I see it, against the rampart in the background, are the two young people with rapt expressions, the bicycle and also the cat and the mouse. And perhaps, or perhaps not, a strand of my hair.

Shortly after my return to Paris, I have dinner with friends who know I'm just back from Jerusalem. The conversation around the table is about holidays, travel.

Some have visited Cambodia, others Guatemala. The hostess turns to me: 'I believe you've been to Berlin recently. It's an amazing city, isn't it?' I reply that I did in fact visit Berlin, two years ago now, and that since then I've been several times to Jerusalem. I don't have time to elaborate because the conversation has already moved on.

Over coffee, one of the guests comes and sits next to me and asks me a question about Israel. I want to talk to her about the photo I didn't take, that I could have taken and which would have been the best of all my photos. But barely is the question out of her mouth when a male guest, who heard her, asks our hostess very hastily and in a very loud voice to give him the recipe for her delicious cake. The conversation immediately becomes general and lively. Everyone talks about the cake which is delicious.

Erased, the photo I wish I could have shown. Not only does it not exist, but what's more it has been erased. Me too, I feel erased.

The mirror has been taken away. Nothing is left.

Photobomb selfie

Photobombing is the art of spoiling another person's selfie by appearing in the camera's field of view just as the picture is taken. And so the selfie will include a figure whose presence was unintended and who 'spoils' the photo by pulling a face or by making a silly gesture. But it also happens that instead of ruining the selfie, the photobomb delights the person who has taken the photo. During the 2014 Commonwealth Games in Glasgow, two young Australian women hockey champions had the thrill of seeing the Queen herself appear in the background of their selfie: beneath her splendid aqua hat was the monarch, gazing into the lens with a big, friendly smile.

Another definition of the selfie photobomb: it is when you take a photo of yourself and an amazing, ridiculous, unpleasant, or, on the contrary, funny, wonderful, magical and fantastic event is captured in the photo. Then, of course, you immediately share the selfie on social media.

I am quite new to taking selfies and so I'm not very good at it, and the most frequent result is that instead of being the main subject, I become the 'bomb' – with a strand of my hair, the corner of my eye or a nostril intruding on a rather lovely landscape.

In the selfie I'm writing about now, the backdrop – a little hazy because of the wire-mesh mosquito screens around the porch – is a clearing on a slope fringed with fir trees and birches. On the left of the photo, you see a section of my forehead, a black eyebrow and my hazel-tinged-with-green eye laughing behind frameless glasses on a rosy cheek, and a clump of frizzy hair – a deep, glossy auburn that I'm rather pleased with. Also in the shot is my left shoulder covered by a low-cut black T-shirt revealing a glimpse of collarbone. The lower right-hand corner of the photo is invaded by an intruder: a huge, incongruous telephone receiver.

*

The screened porch of a house in the woods, in Vermont; fir trees and birches, the wind rustling the leaves, birds; the sad song of the crickets who know that summer is nearly over. It is hard to imagine a more peaceful scene. I'd like to photograph myself with a bear. 'Selfie with bear.' What bear? The brown bear

that lives nearby and who, from time to time, lumbers across the clearing to gorge on blackberries. I saw him again two days ago, while I was drinking my coffee on this same porch. I hope he'll do me the honour of coming by this morning. If I take enough selfies, there's a chance the bear will appear in one of them. It's a bit like trying to photograph a flash of lightning. Snap like mad during a storm and you might succeed.

As I'm about to press the shutter release for the fifth or sixth time, still hoping the bear will put in an appearance, I'm interrupted by the telephone ringing (a real telephone, on a landline). I automatically answer it, and snap myself holding the receiver.

That morning, in a clearing in Vermont, the bear stays out of sight, he won't play my game, and the selfiebomb won't be him, it will be the telephone. Or rather what comes out of the telephone, transforming my selfie forever, and many other selfies and photos at the same time.

A man's voice, pleasant-sounding. A name that means nothing to me at first, then he repeats it and suddenly I remember him very clearly. We'd met twenty-five years ago when he was accompanying his mother who was visiting me in New York. We drank tea. Later, I jokingly said to my sister that I'd wondered whether I'd just served tea to our younger brother, so closely did he resemble our father. But nothing added up, not

the dates or the places. That young man must quite simply have had a father who looked very much like ours. A coincidence. Nothing extraordinary. We forgot about it.

Today, that young man, now in his sixties, is coming out of the telephone like Aladdin's genie coming out of the lamp. He talks, I listen to him and I'm suspicious. What does he want of me, exactly? He says we're related. I want proof. Is he after money? But he doesn't mention money. He talks about genomes. What genomes? He tells me he already has my sister's DNA and the genes have spoken. Now, he wants mine. What for? To gain a fuller picture. He wants to piece together his father. My father. Double helixes wriggle merrily around my porch, blocking out the landscape on my selfie. They upset me, these double helixes, so self-important because they contain the truth. And so I refuse to give the tiniest cell to the young sixty-something, my little brother, who just popped out of the telephone. I'm not interested in genomics.

Forgotten, the selfie with the bear. I have more important things to do. I'm going to spend several weeks Photoshopping, touching up lots of images that aren't images of genomes. A number of family photos, real or imaginary, will need a makeover. Initially, all the images of André, my father, whom I always called by his first name, became blurred. Or he began to float

like a Cartesian diver above the landscapes of my child-hood, and I wonder whether there's a Photoshop pro-gram that will make him regain his footing. And when he's standing upright again and his outline is sharper, he'll be a little different. Inevitably.

I look at photos of the four of us, my parents with my sister and me when we were little: now it feels as if the group is incomplete. There are people missing.

'Would you be shocked if I took up with a lady friend?' my father asked me about ten days after my mother's death, twenty-seven years ago. We were on the plane flying back to Paris.

'A woman I knew in New York a long time ago, before I married your mother,' he added.

I replied:

'No, of course not, if it makes you happy.'

The 'lady friend' was to come and stay with my father in Paris for a while. I silently hoped that she'd cook for him. I wondered how she could have learned of my mother's death so quickly. I told myself that André had his head screwed on right and was resourceful for a man of eighty. I found that both strange and reassuring.

She didn't cook. She was agreeable, discreet. She wasn't trying to take my mother's place. If she were, she'd have cooked. I have very pleasant memories of her. Sitting with our elbows on the kitchen table in the family apartment in Rue Auguste-Comte, we'd drink

tea or coffee and chat. She'd been a dancer in a famous American dance company. She was still beautiful. She would often talk of her son.

'My mother used to say that I had a farmer's hands,' my little brother tells me one day during one of our long telephone conversations.

I burst out laughing.

I laugh because one morning, in that kitchen in Paris where we used to have our breakfast together, his mother looked at my hands and gently said I had the hands of a farmer. I must have answered that they were my father's hands, as she must have noticed. Broad. Stubby fingers. Perhaps she relished this private joke. She gave nothing away.

Stubby fingers and rounded nails are in the genome. But my little brother isn't particularly interested in the farmers' hands, or in the black hair, myopic eyes or shape of the mouth. I wish he were, but he prefers the genome, he says, it's less trivial. He still wants me to let him have mine, but I am adamant in my refusal.

I declare that I would only consider it worthwhile if I thought I might discover I was Mick Jagger's sister.

But now my curiosity about the conception of the man who has dropped like a bombshell into my family photos is piqued. I open boxes, I riffle through the letters from my mother to my grandmother, from whom she was separated for seven or eight months a year. I

wonder in what guise my little brother might feature in this correspondence.

I soon find out. On 10 January 1948, between the list of foods she's just sent to France: pickled eggs and powdered milk, vermicelli and sardines, a packet of instant coffee and two chocolate bars – these parcels sent to her family are an obsession, they take up a large part of each letter – and the 'two girls' perpetual colds', I read: 'André came back delighted with his holiday.'

He had left for New York on 26 December. He was planning to meet up with his friend, the mathematician Henri Cartan, who was coming over from Paris. I imagine André's departure, already 'delighted' to be leaving Chicago for a few days. The city that for him represented the horror, and above all the humiliation, of exile. Rejected by his homeland, even though he was one of its foremost mathematicians, he was condemned to live in Chicago. 'This place is ugly, ugly, ugly,' he wrote to his friends.

I am certain that my mother helps him pack his suitcase. They talk about the things he'll need. Does he already have his 'hat with ears', as my sister and I called his headgear when we were little? That metal-grey aviator hat with flaps that fastened under the chin, which I'd seen him wear every winter until the end of his life.

Cartan's visit was a breath of fresh air from France.

But they failed to meet up. Snowstorm, airports closed. It must have been a huge disappointment for my father. He arrived in New York during the Big Snow, the fiercest blizzard in the city's history. Sixty-seven centimetres of snow fell in twenty-four hours. The city was at a standstill. No subways or buses. Did André telephone his former girlfriend straight away? Did he set out on foot in the snow to meet her, wearing his ear hat, his nose running? When he went for a walk with us children in Chicago, in the bitter North-American winter, he always had a runny nose. No reason for him not to have one in New York during the Big Snow, even when he was on his way to see a very beautiful woman friend.

I have several photos of my father from his 'dandy' period. An elegant young man looking quite pleased with himself, carefully groomed hair and the little smile of a conqueror. These photos are from before the war. There was nothing of the dandy about the man who arrived in New York during the great blizzard of December 1947. He was the man I heard being called, in several situations and in a tone that sounded contemptuous to my child's ears, 'Immigrant Weil'. Exiled, an immigrant. The chapka with ears rammed on his head, a runny nose, he went to seek warmth and comfort from his woman friend. How well I understand him.

Mother, stuck in the dingy hotel room with two sick children, and no means of cooking, is strong and brave. One of the girls is pale and thin, doesn't eat and coughs all the time. The other one is teething, has a temperature and a blocked nose. In the same letter of 10 January, she concludes: 'I was quite pleased that André wasn't there. He badly needed a change of scene, to see people, to rest.'

What worries her most is that André has no office and that his work is suffering. 'André is depressed,' she writes. Mother's letters are lively, down-to-earth and unpretentious; she describes her day-to-day life in great detail, and I can picture everything perfectly. On reading them I feel as if I am witnessing real life. My phantom-phone-baby-brother – he lives a long way away, in the south-west USA – who appears sixty years later can play at genomes if he likes, he can dream about piecing together a genomic André, but what does this kinship created on a cheap genetics website have to do with me? The present feels dead and false. It is the past that is real and alive.

I go back to André's return to Chicago and re-read the entire sentence this time: 'André came back delighted with his holiday, less so to find himself in a sick bay!' I can imagine only too well his disgusted look at the scene that greets him: the ailing children and the dreary hotel room where he is unable to work.

And France is so far away. And my mother, constantly fretting about her parcels of noodles and butter that probably turned rancid before it even arrived, sweets for the children and chocolate too. And always powdered milk. Soon she'll be sending shoes.

Meanwhile, between coughing fits, I play hopscotch. I raise clouds of dust from the ugly, faded geometric patterns on the hotel carpets. Elderly Russian ladies, permanent refugees resigned to their destiny, kind and without bitterness, make dolls for me which I still have to this day. Tiny princesses with velvet dresses and tiaras adorned with shiny stones.

The deed is done. My little brother has been conceived. His mother must have thought that André would make a good biological father, that he was endowed, yes, that's the word, with good genetic credentials. So perhaps it is perfectly logical that, sixty years later, her son wants to piece together the genome of his famous mathematician father.

I have a hard job getting my little brother to send me a photo. Not easy because he doesn't like photos. I am moved by the resemblance. There exists on this earth a man who has as many of André's genes as I do. I suddenly see the double helixes as friendlier, more graceful and in full colour, like in biology books. I wonder what colour the matching segments on my helixes and on those of this man whom I met once, could be painted.

Over the telephone, we surmise whether we have lots of other brothers and sisters and whether they're good at maths. We laugh.

The photos of André will remain a little blurred. No Photoshop program will be able to improve them, but it is of no importance. I am more successful in tweaking the family photos. For example, the one where the four of us are posing, the parents and the two little girls, next to the big American car (of course) which André must have hired or borrowed to take us to the countryside north of Chicago to marvel at the autumn colours. It must be in 1954. Now I should add my little brother to this pretty photo. Or rather, he slips himself in. He has clambered up onto the running board of the car and is swinging on the car door. My sister and I don't swing from the car doors. Even if we were tempted to, we know how our father would react. But our little brother is swinging. It's only natural, he's a boy! André slaps him. A slap which, in reality, was given in a northern New York suburb where, at around that time, André went for a drive in a car he must have hired for the occasion, and my little brother swung on the door.

'He hauled me off and slapped me. I was furious,' he tells me. 'Some time later, for Christmas, André sent me a very fine wooden construction set. I asked my mother if I could accept a gift from someone I didn't

like or whether afterwards I would have to like him. She said I didn't have to like him.'

It is because of that slap, I think, and perhaps too because of that construction set, such a natural, plausible gift from father to son, that I find myself, all these years later – even though the main protagonists in this story are long since dead – sitting with my elbows on another kitchen table, in Vermont, a very long way from Rue Auguste-Comte, holding in front of my mouth a transparent plastic tube with a little funnel on top. I move my lips forward to spit, spit cells, spit my genome. My husband watches to make sure the tube fills up properly. The saliva must go up to the white line. Then you remove the funnel, and this triggers a closing mechanism, you screw on the top, shake the tube, timer in hand, then you pack up the tube in the box provided and rush out to post it.

I will discover that I am well and truly my father's daughter and the sister of my new little brother, and also that I am three per cent Neanderthal.

Photograph of Sylvie Weil by Marc Riboud,
courtesy of Catherine Riboud